Vincent's Portraits

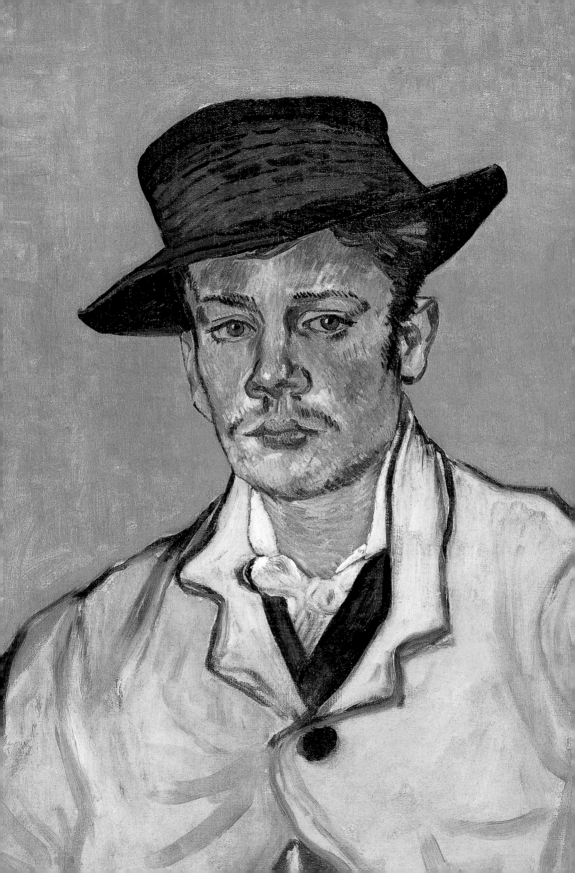

Vincent's Portraits

Paintings and Drawings by Van Gogh

Ralph Skea

87 illustrations

 Thames & Hudson

For my wife, Kate

Ralph Skea worked as a town planner and architect, and was for many years Senior Lecturer in European Urban Conservation at the University of Dundee, Scotland. He is a painter, and his works have been exhibited widely since 1973. He is the author of *Vincent's Gardens* and *Vincent's Trees*.

Quotations are taken from *Vincent van Gogh – The Letters*, published in 2009 by Thames & Hudson. The number of the letter is in brackets after each excerpt.

Unless otherwise indicated, all works are paintings in oil on canvas.

FRONT COVER
[64] *Self-Portrait* (detail), Saint-Rémy, August 1889

PAGE 6
[46] *Portrait of Eugène Boch ('The Poet')* (detail), Arles, September 1888

BACK COVER
[59] *'La Berceuse' (Madame Augustine Roulin)* (detail), Arles, 1888–1889

PAGE 38
[22] *Portrait of Vincent van Gogh* (detail), Henri de Toulouse-Lautrec, Paris, 1887

PAGE 2
[40] *Portrait of Armand Roulin* (detail), Arles, November–December 1888

PAGE 82
[72] *The Sower* (detail), Saint-Rémy, October 1889

OPPOSITE
[66] *Portrait of Madame Trabuc* (detail), Saint-Rémy, September 1889

PAGE 98
[75] *Portrait of Doctor Gachet* (detail), Auvers-sur-Oise, June 1890

Vincent's Portraits © 2018 Thames & Hudson Ltd, London
Text © 2018 Ralph Skea

First published in 2018 in the United States of America by Thames & Hudson Inc., 500 Fifth Avenue, New York, New York 10110

www.thamesandhudsonusa.com

Library of Congress Control Number 2017945799

ISBN 978-0-500-51966-0

Printed and bound in China by C&C Offset Printing Co. Ltd

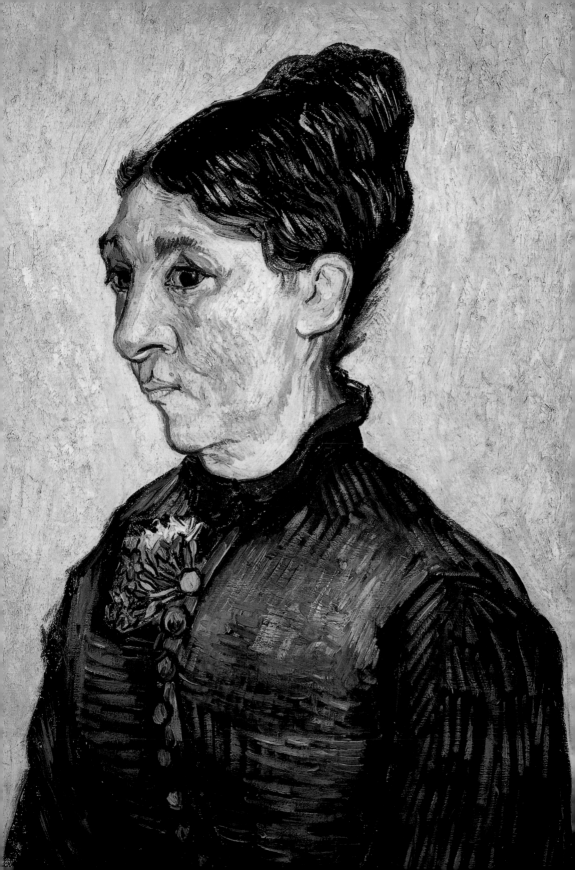

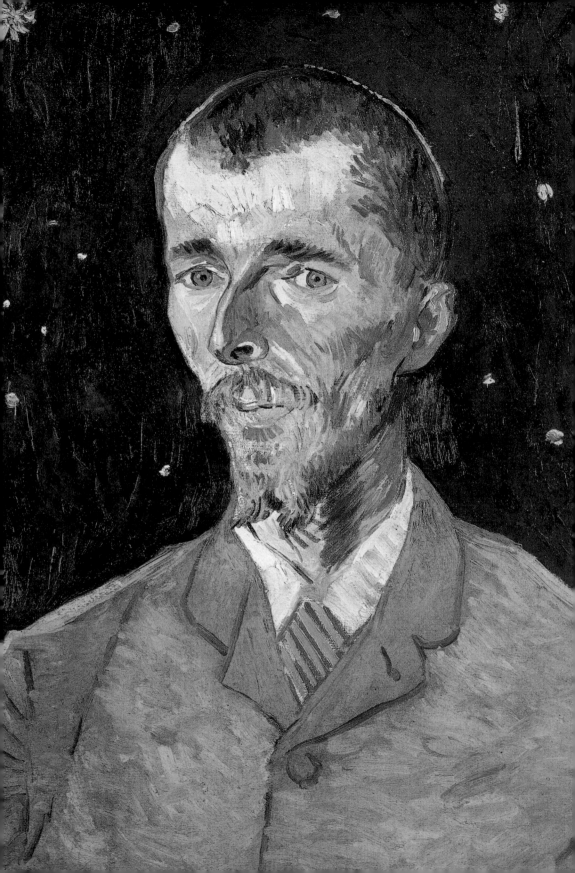

Contents

Introduction:
'And painted portraits have a life of their own that comes from deep in the soul of the painter...'

Despite his posthumous fame as a painter of flowers, still-lifes, gardens, landscapes and city scenes, during his lifetime Vincent van Gogh (1853–1890) believed that his portraits constituted his most important body of work. Although as an artist he was 'touched by so many very different things' (430), he was nevertheless committed above all to the art of portraiture. In this he saw himself as being different from his contemporaries: 'What I'm most passionate about, much much more than all the rest in my profession – is the portrait, the modern portrait' (879). By the 'modern portrait' he meant avoiding bland, photographic likenesses produced by conventional painting techniques; rather, he sought to convey the essential character of his models by means of pure colour and expressive brushwork. The resultant portraits, he hoped, would 'have a life of their own' (547), and would reflect the diversity of contemporary society.

[1] *Head of a Peasant Woman with Red Cap*
Nuenen, April 1885
While living in Nuenen, North Brabant, Vincent painted many portraits of the peasant families working nearby. Inspired by Frans Hals (1582/3–1666), Vincent used a heavily loaded brush and a sketch-like technique to compose this haunting portrait, full of compassion, that conveys the hardships of rural living that he saw projected on the woman's face.

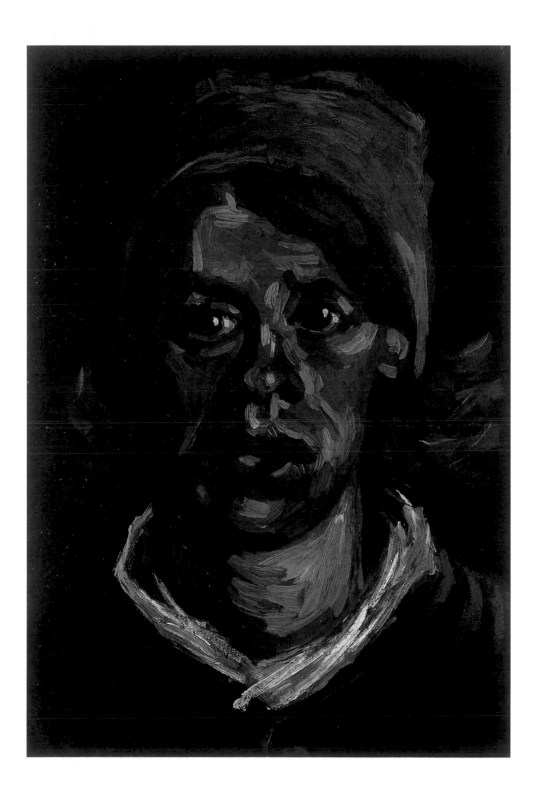

His empathy for the plight of the rural poor in the Netherlands, where he grew up, is evident in his early portraits [1]. Human sympathy was something he hoped to express above all else in these paintings of peasants: 'I want to reach the point where people say of my work, that man feels deeply and that man feels subtly' (249). Likewise in urban areas, his preference was for models from the working classes: servants, labourers, barmen, dancers and shopkeepers – the types of people he met in streets, bars and cafés. As a portraitist, Vincent believed that, compared with their bourgeois counterparts, these working people possessed 'a power and vitality' that had to be captured on canvas 'with a firm brushstroke, with a simple technique' (547).

During his three-month stay in Antwerp, from the end of November 1885 until the end of February 1886, while on his way to Paris, Vincent painted a particularly evocative portrait of this type of working-class person [2]. His model was a vivacious young hostess and dancer in a 'café chantant', a popular city nightclub. There she spent long hours drinking with male customers before posing for Vincent.

'I tried to get something voluptuous and sad at the same time' (550)

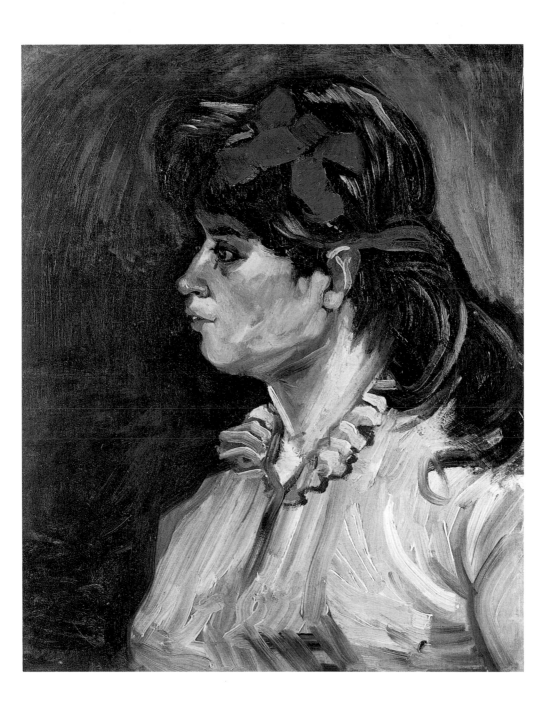

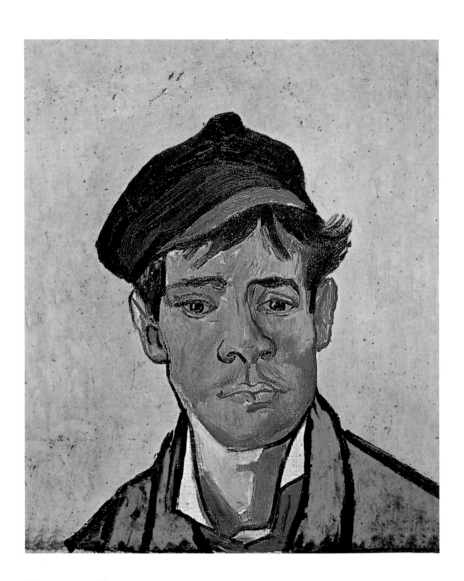

[3] *Young Man with a Cap*
Arles, December 1888
Experiencing the pure sunlight of
Arles, Vincent saw that a 'modern
portrait' could be achieved by means
of flat areas of bright colour and by the
avoidance of shadows. In this example,
the simplified forms and the use of
outlining indicate the influence of
Japanese woodblock prints, of which
Vincent was an avid collector.

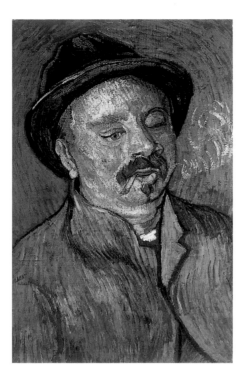

[4] *Portrait of a One-Eyed Man*
Saint-Rémy, October 1889
Vincent classified many of his
models as 'types' – broad categories
of people. Although it was the 'type'
of person that initially attracted
him, often prompted by his reading,
he also aimed to capture their
unique personalities in his portraits
of them. In this portrayal of a
mentally ill man, Vincent conveys
his model's underlying sadness.

From February 1888 until May 1890, Vincent lived in
Provence, and it was there that he perfected his concept of
the 'modern portrait'. He shunned both detailed realism and
academic painting methods: 'I seek it by way of colour' (879).
The result was a number of vibrant portraits in which stylized
design and decorative colours predominate [3].

Vincent sought out people who seemed to him to epitomize
the struggles of rural and urban life, often selecting models
who reminded him of fictional characters created by some of
his favourite novelists, such as Émile Zola (1840–1902). Such
literary inspirations often underpinned his portraits, though
without resulting in purely illustrative images [4].

As an extremely well-read artist, Vincent often included
contemporary novels as important components in his
portraits; in certain still-lifes, piles of his own favourite books
are the main features depicted. In such paintings, his own
presence is almost palpable [5].

'Books and reality and art are the same kind of thing for me' (312)

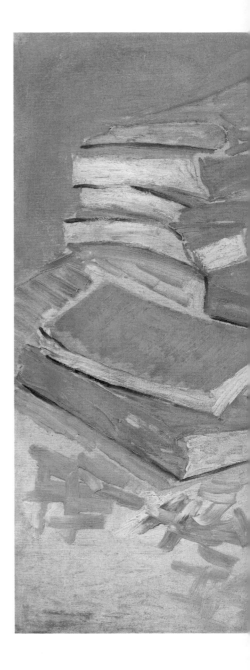

[5] *Still-Life: French Novels*
Arles, October 1888
The novels have not been self-consciously arranged; rather, their random pattern on the table has been perceived as being sufficient for the creation of a harmonious composition. Because we know that these books belonged to Vincent, this still-life can be viewed almost as a virtual self-portrait.

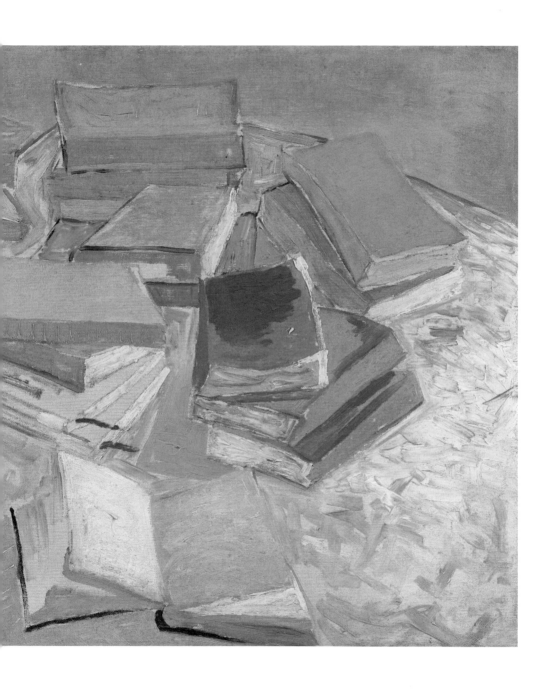

Over the course of only five years during his ten-year career, Vincent created thirty-nine self-portraits: thirty-seven oil paintings and two drawings. Due to the number of self-portraits he produced, and their high quality, Vincent is acknowledged as one of the greatest self-portraitists in the history of Western painting [6]. Only one of his heroes, Rembrandt (Rembrandt Harmenszoon van Rijn, 1606–1669), was more prolific, but over a career spanning forty-four years. Vincent's self-portraits are noteworthy for their intensity; they seem to encapsulate the depths of feeling and psychological insights that he pursued in his portraits of others.

Because he completed such a large number of self-portraits, and due to his current international fame, Vincent's face is now one of the most familiar in art history and popular culture. But beyond his recognizable facial features, the self-portraits reveal varied facets of his personality, from his vulnerability to his assertiveness.

The artist known by most people today as 'Van Gogh' chose to sign his work as 'Vincent'. When asked by an acquaintance why he did not use his surname for this purpose, he explained that nobody outside the Netherlands would ever be able to pronounce his name correctly. In this, of course, he has been proved correct! As a consequence, he adopted 'Vincent' as his artistic signature, a name, he explained, that everyone, everywhere, would be able to pronounce. This was confirmed during his sojourn in the south of France, where he was known simply as 'Monsieur Vincent' by all his acquaintances. For this reason, therefore, in this book the painter who is still renowned today as 'Van Gogh' is referred to most often as 'Vincent' – as he himself preferred to be known.

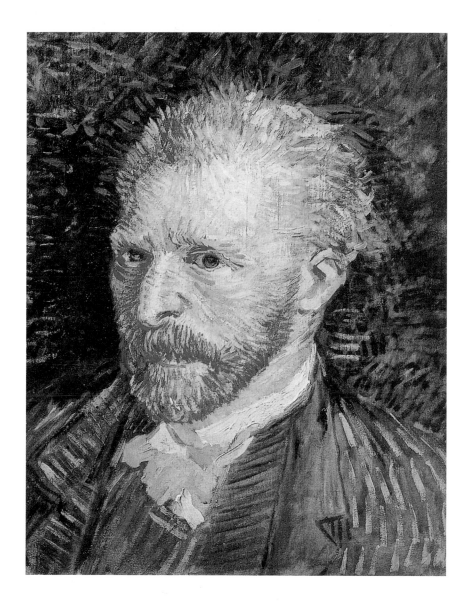

[6] *Self-Portrait*
Paris, Autumn 1887
Although all Vincent's self-portraits share
a notable intensity, they are often unique
in terms of mood and technique; being
self-taught, the self-portrait provided a
basis for solitary experimentation. Here
he used short lines of pigment – striations
– to unify his composition.

In 1880, after abandoning his five previous careers – trainee art dealer, schoolteacher, curate, bookseller, missionary – at the age of twenty-seven, Vincent van Gogh decided to devote the rest of his life to drawing and painting. Endeavouring to master a wide range of techniques, in the next ten years he produced almost 900 paintings and 1,100 drawings, many of them of the highest quality. This explosion of creativity is unprecedented in the history of Western visual art. Furthermore, as early as 1883, he had formulated an ambitious aim for his work as a whole: 'I'm concerned with the world only in that I have a certain *obligation* and *duty*, as it were – because I've walked the earth for 30 years – to leave a certain souvenir in the form of drawings or paintings in gratitude. Not done to please some movement or other, but in which an honest human feeling is expressed' (371). Vincent's remarkable 'souvenir', his body of work redolent of 'human feeling', is the main reason why he is so revered as an artist today. However, Vincent's 'souvenir' has often been eclipsed by the legend of his life – his mental illness, self-mutilation, and suicide – thus obscuring his achievements as a remarkably gifted painter and writer.

During Vincent's ten-year career, he settled in eleven different locations – in some places for over a year, in others for only a few months. This restlessness he recognized as being a crucial aspect of his personality: 'It always seems to me that I'm a traveller who's going somewhere and to a destination. If I say to myself, the somewhere, the destination don't exist at all, that seems well argued and truthful to me' (656).

It is not only Vincent's portraits that illuminate the route that he undertook as a 'traveller'. His remarkable letters, describing his thoughts and feelings in compelling prose, constitute a parallel record of his personal quest. For that reason, quotations from some of his 819 surviving letters are employed throughout this book to elucidate the significance for Vincent of portrait painting as an art form.

In chronological fashion, this book charts the main 'destinations' in which Vincent painted his portraits.

Chapter 1 demonstrates that his earliest portraits, created in the Netherlands between 1880 and 1885, have a powerful, brooding presence. However, during his stay in Paris, described in Chapter 2, he discovered the vibrant colours of avant-garde styles. Chapter 3 reveals that after moving to Arles, in the south of France, his intoxication with colour and bold designs reached its zenith in his Provençal portraits. Even when seeking refuge in the lunatic asylum at Saint-Rémy, where he suffered psychotic attacks, he was still able, during spells of remission, to paint portraits of emotional power. Indeed, Chapter 4 speculates that perhaps his finest self-portraits were painted in this place of voluntary confinement. That he eventually craved a return to his northern-European roots is outlined in Chapter 5: his final 'destination' being Auvers-sur-Oise, in Northern France. Here he painted his last, enigmatic portraits before his suicide in July 1890.

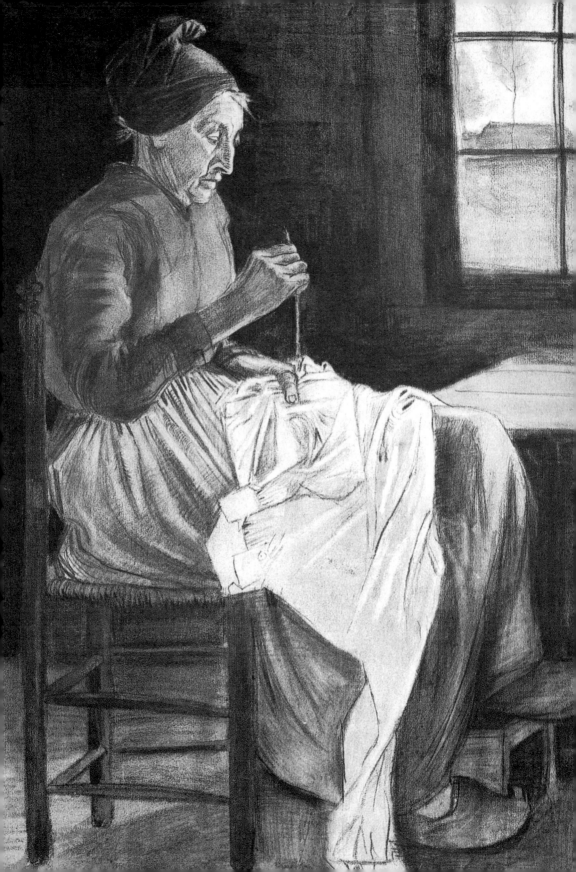

CHAPTER 1

The Netherlands

[7] *Woman Sewing*
Opaque watercolour, wash,
black chalk on laid paper
Etten, October–November 1881
This is the most accomplished
portrait drawing from Vincent's
Etten period. Given that he was a
self-taught artist, it demonstrates
how quickly his innate talents
emerged. The composition
and mood are reminiscent of
seventeenth-century Dutch
painting, in which a single female
figure, seated by a window, quietly
at work on a domestic chore, was a
common subject.

'Ah, *it seems to me more and more that* people *are the root of everything*'

From the beginning of his career as an artist in the Netherlands to the last months of his life in France, Van Gogh believed that his main mission as a painter was to produce insightful portraits of ordinary working people. But his decision in 1880 to become an artist was a sudden one, taken after a distressing mental crisis during his employment as an evangelist in the Borinage, a poor mining district in Belgium. Such was the severity of his manic attack – sleeping outside, giving away most of his food and clothes, speaking incoherently – that his father, Theodorus van Gogh (1822–1885), eventually considered admitting him to the Belgian lunatic asylum of Geel. Fortunately, Vincent, now aged twenty-seven, recovered his composure relatively quickly, and, with the support of his brother Theo (Theodorus van Gogh, 1857–1891), decided to devote himself to art rather than to religion. Using illustrations as his source material, he commenced his training by making copies of works by his favourite French artist, Jean-François Millet (1814–1875). Millet's images of nineteenth-century rural life haunted Vincent, and when he started to draw and paint portraits of peasant farming families in the Dutch villages of his native province of North Brabant, it was Millet who proved to be his inspiration; indeed, Millet's work exerted a strong influence over Vincent for the rest of his artistic career.

The first village in which he was to hone his draughtsmanship skills was Etten, where his father was a parson of the Dutch Reformed Church. Emulating Millet, Vincent began to draw, from life, a series of figure studies and portraits of rural workers occupied in a wide range of activities: men digging fields and sowing crops; women churning butter, nursing children and mending clothes [7].

But once more his parents became alarmed by his erratic, abrasive behaviour; conflicts arose daily and so, in December 1881, Vincent decided to leave the increasingly

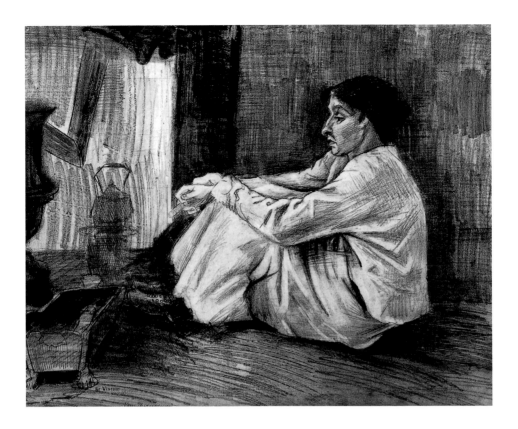

tense atmosphere of the parsonage in order to continue his career in The Hague. There he started living with a pregnant prostitute, Clasina ('Sien') Maria Hoornik (1850–1904). His parents and relatives were shocked at what they saw as his outrageous behaviour, while Vincent believed that he was saving Sien, her children and her mother from inevitable destitution, in line with his humanist principles and evangelical Christianity. But, of course, he had no income apart from his brother's allowance – intended solely for the development of his art. Inevitably, this led to tensions between Vincent and Theo.

Vincent created many accomplished drawings of his mistress, whom he believed to be a victim of urban life [8]. And it was not only in his drawings of Sien that he hoped to convey his affectionate feelings, but also in his portraits of

[8] *Sien with Cigar, Sitting on the Ground by the Stove*
Pencil, white chalk and ink on double laid paper
The Hague, 1882
All of Vincent's portraits of Sien possess a melancholic mood. As he empathized with her constant struggle to feed her children, his drawings of her evoke a deep sympathy for her plight.

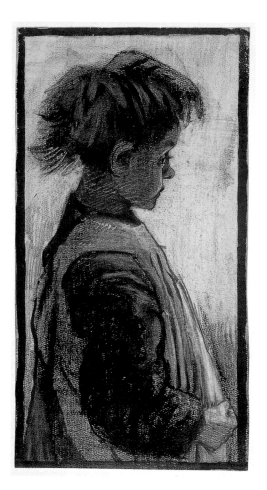

[9] Girl with a Pinafore
Lithographic crayon, graphite, ink, with pen
and brush, opaque watercolour, scratched,
on watercolour paper
The Hague, December 1882–January 1883
This thoughtful little child is believed
to be Sien's five-year-old daughter,
Maria Wilhelmina (1877–1940). That
Vincent drew an ink frame around this
drawing indicates that he believed it to
be particularly successful.

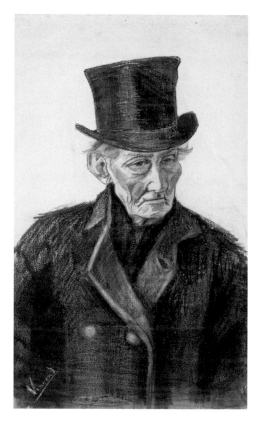

[10] Old Man with Top Hat
Lithographic crayon, graphite, ink, with pen
and brush, scratched, on watercolour paper
The Hague, December 1882–January 1883
The model for this powerful portrait
was Adrianus Jacobus Zuyderland
(1810–1897), who posed for a number of
drawings. Vincent very much admired
his stoical nature and proud posture.

her children. Vincent was very fond of her young daughter, and created some tender images of her [9]. He wanted drawings such as these to evoke emotion without resorting to sentimentality: 'I want to make drawings that *move* some people' (249). Equally moving are his drawings of the poor, elderly residents of the almshouses located in The Hague [10]. Previously, while living in London, he had been impressed by a series of drawings, 'Heads of the People', featured in the English illustrated journal *The Graphic*. Inspired by his collection of these magazines, Vincent now embarked on his own series of drawings of working-class people that he encountered throughout the Netherlands.

At the outset of his career, in 1880, Vincent was determined to master the principles of drawing before embarking on the creation of any oil paintings. It was around August 1882 that he began experimenting seriously with the oil-painting medium, and especially with colour. Vincent was confident then that, after all his struggles to forge a career, visual art was indeed his true métier: '...painting is in my marrow' (260).

Furthermore, he believed that, through the quality of his art, he could redeem himself in the eyes of his critics – those family members and acquaintances whom, Vincent believed, perceived him to be a 'nonentity or an oddity or a disagreeable person' (249). He remained defiant: 'through my work I'd like to show what there is in the heart of such an oddity, such a nobody' (249). And in a remarkable manner he achieved this redemption, albeit posthumously.

On 11 September 1883, Vincent left The Hague, and his increasingly problematic family life with Sien, never to return. After a brief painting expedition to the remote province of Drenthe, where he became increasingly depressed, he decided to visit his parents in Nuenen, North Brabant, where his father had taken up a new post as parson. It was here, between December 1883 and November 1885, that Vincent was to paint the most perceptive portraits of his Dutch period. Obsessively, he drew and painted the impoverished farming families living in insanitary cottages close to the parsonage. In contrast to Vincent's privileged

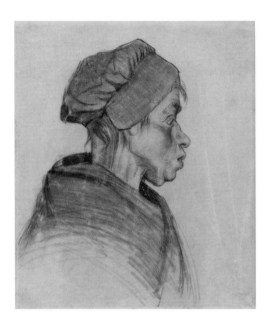

[11] *Head of a Peasant Woman*
Black chalk on wove paper
Nuenen, December 1884–May 1885
As this bleak drawing demonstrates,
existence for peasant women,
working nearby the bourgeois
comforts of the parsonage, was
harsh and unrelenting. Although
the woman was not yet old, her
appearance confirms the severity
of peasant farming life.

[12] *Young Man with a Pipe*
Pencil and transparent watercolour,
on watercolour paper
Nuenen, March 1884
Vincent drew his seated model in
profile, creating a striking, balanced
composition. The dark coloration
and pronounced outlining give this
portrait the quality of a silhouette.

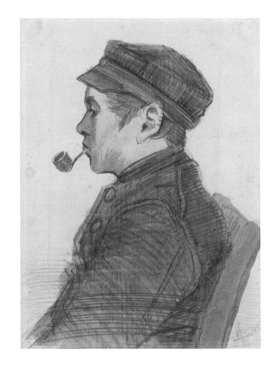

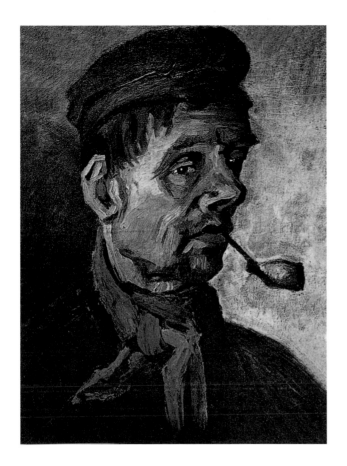

[13] *Head of a Peasant with a Pipe*
Nuenen, January 1885
The 'tronie' inspiration of this
painting is most evident in
its stylized forms; like many
seventeenth-century Dutch 'tronies',
Vincent's portrait has a hint of
caricature. The red scarf is evidence
of his growing interest in bright
colour, which would dominate his
career in France.

existence, a typical peasant's life was one of hard labour:
eking out a living growing potatoes and wheat in poor
sandy soil, and often suffering from malnutrition and
chronic illness.

In powerful drawings, Vincent portrayed his female
models with an unflinching realism [11]. However, certain
of his portrait drawings of young male farm workers project
a much more impassive mood. One such study, showing
a young peasant smoking a pipe, has a contemplative
quality, reflecting the adolescent's calm demeanour [12].
In contrast, an oil painting of an older man with a pipe is
reminiscent of the 'tronie' style of portrait painting, popular
among seventeenth-century Dutch artists [13]. A 'tronie'

[14] *Head of a Woman*
Pencil, pen and brush in brown ink,
with brown wash on laid paper
Nuenen, December 1884–
January 1885
In this intriguing ink drawing,
the skilful use of cross-hatching
and dark wash creates a mournful
mood. The portrait's precision of
line is reminiscent of the Rembrandt
etchings that Vincent had studied.

[15] *Head of a Young Peasant
in a Peaked Cap*
Nuenen, March 1885
This young man's stare is both
forceful and unsettling. Vincent
seems to have empathized not only
with his model's vulnerability,
but also with his youthful
determination to succeed in his
work – cultivating low-yield crops
in the fields around Nuenen.

was a character study of a social 'type', an anonymous
person – usually from the working-classes. Although not
a commissioned portrait, a 'tronie' sought to embody the
powerful personality of the artist's model. Vincent greatly
admired Frans Hals's 'tronie' portraits, not only for their
psychological insights, but also for their forceful, loose
brushwork and daring use of thick paint – termed 'impasto'.

The pen-and-ink medium offered Vincent the opportunity
to closely analyse the faces of his models in a highly detailed
manner. Between December 1884 and January 1885 he drew
a series of fifteen small ink portraits of male and female
peasants [14]. All of these works are examples of Vincent's
aim of creating compassionate images using very 'simple
means' (371).

In early 1885, Vincent painted an ambitious series of fifty
portrait heads of the local farmers and their families. Of
these works, forty-seven have survived. Many of these studies
exhibit an intense, disconcerting gaze [15]. It is as if Vincent

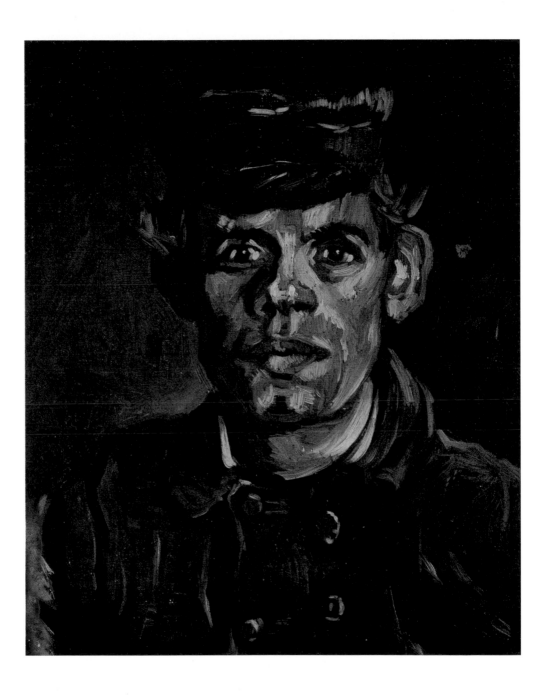

'the painting of the peasants eating potatoes that I did in Nuenen is after all the best thing I did' (574)

had been able to tap into his models' hidden thoughts. He did not consider these portrait heads self-contained works of art, but part of a unified series: 'for my part, I don't view my studies in isolation, but always have in mind the work as a whole' (371). Some of these portraits were used as the basis for his famous figure composition *The Potato Eaters* [16].

Weavers, of which there were a large number working in and around Nuenen, provided Vincent with additional models. Weaving constituted an important cottage industry, with farmers and their wives supplementing their meagre incomes by weaving rolls of brightly coloured cloth called 'bontjes'. Vincent became fascinated by the dark workshops, with the weavers seemingly entrapped in their great looms. These images display the strong contrasts of light and deep shade – 'chiaroscuro' – that Vincent admired in Rembrandt's paintings [17].

A distinctive sub-group of portrait heads shows female peasants wearing traditional caps or 'poffers'. This form of flamboyant headgear, worn on special occasions, became the dominant feature of some of Vincent's Nuenen portraits

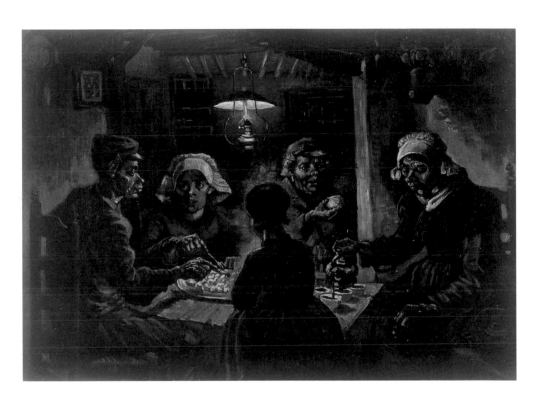

[16] *The Potato Eaters*
Nuenen, April 1885
This powerful representation of
a rustic meal was the culmination
of all Vincent's portrait studies
in Nuenen. Though he struggled
to integrate the five figures into a
cohesive composition, he believed
that he had succeeded in depicting
the family's meagre meal in a
truthful, unsentimental manner.

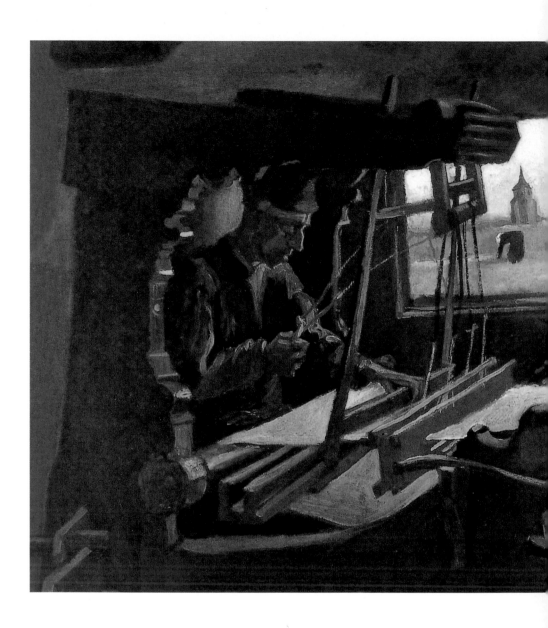

[17] *Weaver near an Open Window*
Nuenen, July 1884
In the weaver's claustrophobic
workshop, a small window is the only
source of daylight. It also provides a
tantalizing glimpse of the old church
tower – soon to be demolished – and of
a peasant woman at work in the field.
Thus interior and exterior spaces have
been united in this meditative image.

[18] *Head of a Peasant
Woman in a White Cap*
Nuenen, April 1885
The peasant's elaborate cap
contrasts with her weather-beaten
face. Vincent applied thick paint
in broad sweeps to emphasize the
portrait's key components. His
model, for this and many other
portraits, was Gordina de Groot
(1855–1927), in whose appearance
Vincent found a particularly
pensive quality.

[18, 19]. He painted the caps with brushstrokes of thick
pigment, suggesting the elaborate folds without resorting
to over-precise detail: 'Not always literally exactly – rather
never exactly – for one sees nature through one's own
temperament' (492).

Vincent's father died suddenly from a stroke on 26 March
1885. For weeks beforehand he and Vincent had been arguing
over aspects of Christianity and morality. Therefore, it is
significant that, soon after his father's death, Vincent painted
one of his most enigmatic still-lifes showing a massive open
bible [20]. The painting is composed of many symbolic

[19] *Head of a Peasant
Woman in a White Cap*
Nuenen, March 1885
This peasant woman, despite
having donned her finest cap for
her portrait, seems uncomfortable
posing for the parson's son.
Although Vincent paid his
models to sit for him, many of
the agricultural workers were still
reluctant. But Vincent remained
obsessed with recording their facial
features: 'At the point where I now
am, though, I see a chance of giving
a felt impression of what I see' (492).

[20] *Still-Life with Bible*
Nuenen, April 1885
Given this painting's large size,
complex composition, and precise
execution, it is astonishing to learn
from Vincent's letter to Theo that
it had been completed extremely
quickly: 'I painted this *in one go*,
in a single day' (537).

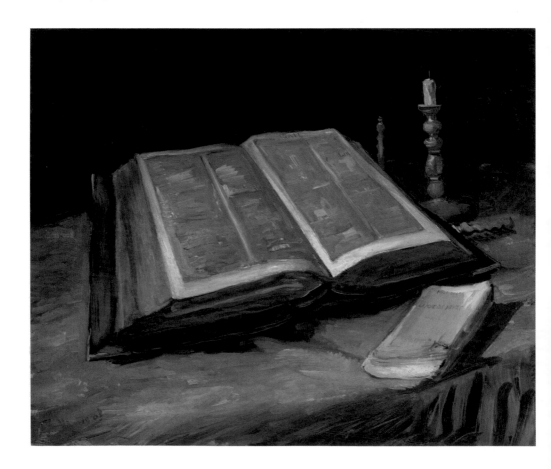

elements. The bible looms large in the picture, just as the gospels had done in his father's life, and in Vincent's own early adulthood. The extinguished candle motif, as in much early European painting, signifies the brevity of life. The huge bible is open at Isaiah 53, a verse that speaks of 'God's suffering servant' and the 'man of sorrows' – terms that would have resonated with both Vincent and his father. The addition of Vincent's own copy of Émile Zola's novel *La joie de vivre* (1884) – an ironic title for a work dealing with the tribulations of contemporary life – underlines the complex themes of this image. This mysterious painting could thus be viewed as an oblique, joint portrait of father and son.

Given that he is an artist renowned for his use of pure primary colours, it is perhaps surprising that all of Vincent's greatest Dutch portraits are based on a rather sombre range of colours: burnt umber, ochre, gold, deep red, silver-white and black. But Vincent's use of these colours is perfectly in tune with his Dutch heritage, recalling in particular the seventeenth-century portraits by Hals and Rembrandt that were his inspiration. Furthermore, the distinctive range of colours he employed matched the character of his models, and the muted tones were a consequence of the dim light he experienced in his native country during the autumn and winter months. It should be remembered also that these moving portraits were painted during the first half of his career – and thus they constitute an important five-year element of his life's work, and are not just a bleak prelude to his later, colourful portraits. His spectacular use of a full range of pure colours in his portraits was only to emerge during the next five years, when he was living in Paris, and later in the south of France.

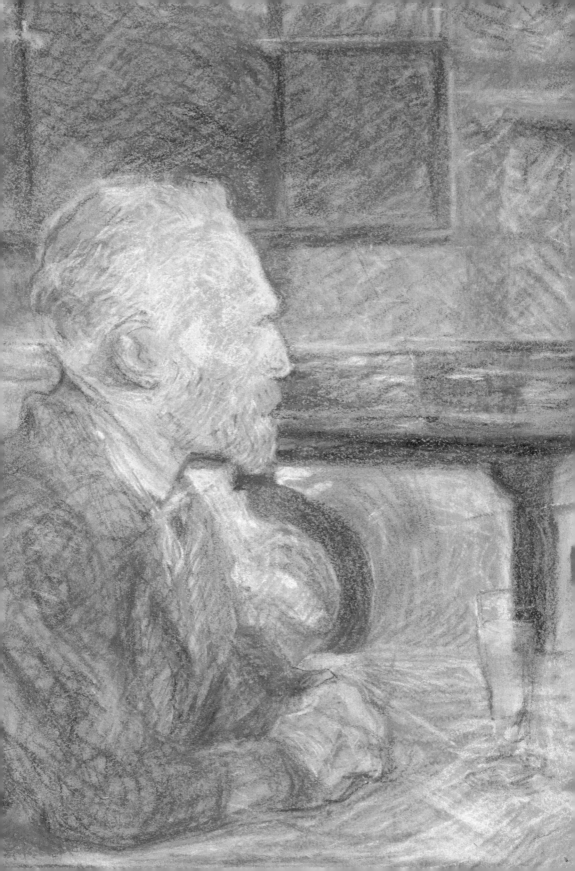

CHAPTER 2

Paris

'...it gives me air when I make a painting...'

Although it had long been planned that Vincent and his brother would live together in Paris, where new artistic ideas flourished and the art market was buoyant, Theo had wanted to delay matters until he had managed to rent a larger apartment. However, Vincent was so excited by the prospect of immersing himself in the capital's art world that, on 28 February 1886, he arrived unexpectedly in Paris from Antwerp. He knew that Theo would be dismayed by his impetuous decision, as his note, sent via a station porter, suggests: 'Don't be cross with me that I've come all of a sudden. I've thought about it so much and I think we'll save time this way' (567).

But just as Theo had predicted, his small apartment at 25 rue Laval could not satisfactorily accommodate an aspiring art dealer and an untidy practising painter. Quite quickly, therefore, Theo rented a much larger apartment at 54 rue Lepic, where Vincent could have a studio. Another advantage of this property was that the main rooms had fine panoramic views of the city centre; Vincent painted two atmospheric cityscapes from his studio window. In both works he explored a painting technique that he had not encountered in the Netherlands or Belgium – 'Pointillism' [21].

This style had been pioneered by Georges Seurat (1859– 1891) and Paul Signac (1863–1935). Vincent came to know the latter very well during his stay in Paris. Pointillism, or 'Divisionism' as Seurat and Signac preferred to call it, was a more methodical branch of Impressionism. Instead of using intuitive, spontaneous brushstrokes, the Pointillists advocated a highly controlled, restrained application of small 'points' or discrete blocks of pure colours. These were to be arranged according to the colour spectrum in complementary sets – red and green, blue and orange, violet and yellow. By employing these juxtapositions, a vibrant illusion of light could be achieved. Vincent became fascinated by pointillist

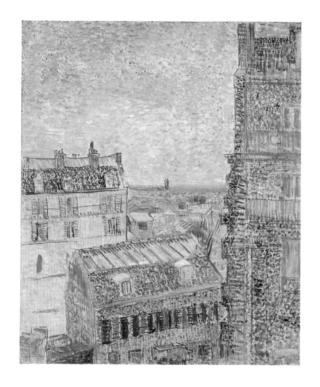

[21] *View of Paris from Vincent's Room in the Rue Lepic*
Paris, Spring 1887
Despite the cramped atmosphere of Montmartre, and his periods of self-doubt and anxiety, Vincent found painting in his new studio to be a welcome solace: 'it gives me air when I make a painting, and without that I'd be unhappier than I am' (574). In fact, Vincent's cityscape has a light, spacious quality due to his experimentation with pointillist technique.

theory, but he applied it in a highly personalized manner when painting his landscapes, still-lifes and portraits.

Although Vincent had lived in Paris before, as an apprentice art dealer, he now found the city particularly hectic. Furthermore, as he was prone to periods of anxiety and depression, he knew that he would have to be resilient if he was to succeed here as a painter: 'You have to be strong to endure life in Paris' (574). Fortunately, he was to make friends with a small group of avant-garde painters who were to prove supportive during his early months in the city. Soon after his arrival in Paris, Vincent had enrolled at the studio of a well-known artist, Fernand Cormon (1845–1924), where he hoped to refine his painting and drawing techniques. But after three months he left the studio, not finding the standard of tuition particularly useful. However, during his time there he formed a strong bond with four of his fellow pupils: Émile Bernard

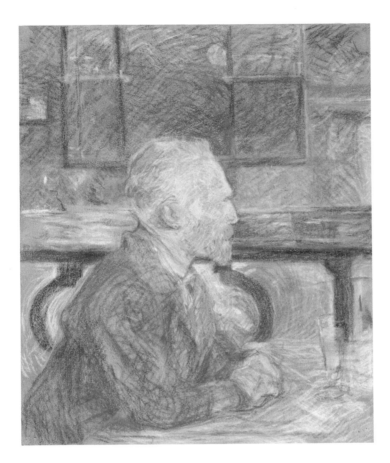

(1868–1941), Henri de Toulouse-Lautrec (1864–1901), Louis Anquetin (1861–1932), and Arnold Koning (1860–1945). For the rest of Vincent's life, Bernard was to remain his closest friend and the recipient of twenty-one of his most perceptive letters; these Bernard was to publish after his friend's suicide. Toulouse-Lautrec immortalized Vincent in a different way, by creating a beautiful pastel drawing of him, in profile, sitting in one of his favourite café-bars [22].

The five friends continued to encourage one another, and even sought out venues to exhibit their work as a group. Given his past experience in the art trade, Vincent assumed the role of co-ordinator. But as well as relishing this artistic companionship, he enjoyed having his own quiet studio

in Montmartre. Like all the great self-portrait artists in history, Vincent studied his own facial features with forensic intensity, as is evident in his famous single sheet of self-portrait drawings [23]. It has been speculated that the main portrait in this set of details served as the basis for the iconic painting in the collection of the Art Institute of Chicago [24].

In the spring of 1887, Vincent painted a vibrant portrait of his thirty-three-year-old Scottish friend, Alexander Reid (1854–1928) [25]. The son of a prominent Glasgow art dealer, he had been sent to Paris by his father to become an apprentice art dealer. As Theo's colleague at Boussod, Valadon & Cie, Reid became friendly with Vincent. Both of Vincent's two

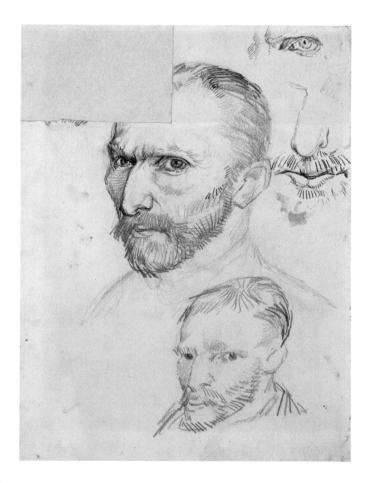

[23] *Two Self-Portraits and Several Details*
Pencil, pen
Paris, January–June 1887
The central self-portrait in this sheet of studies has been achieved by means of subtle hatching using pencil and ink. Vincent's gaze is one of extreme concentration.

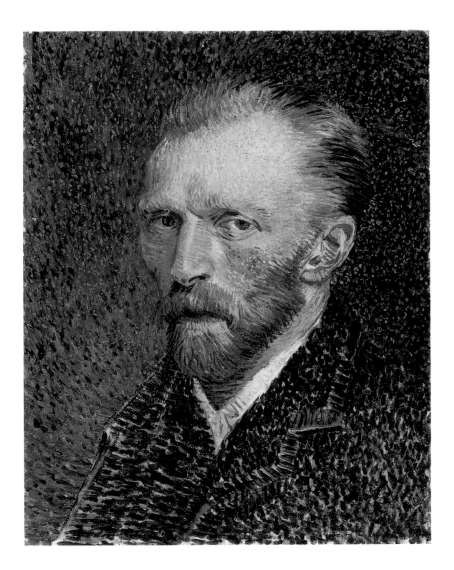

[24] *Self-Portrait*
Oil on cardboard
Paris, Spring 1887
Vincent's Parisian self-portraits
often display an eclectic mix
of painting techniques. In this
portrait, although his beard, hair
and face have been rendered using
lines of pigment, his jacket and the
background are richly patterned
with pointillist-style dots and
patches of bright colour.

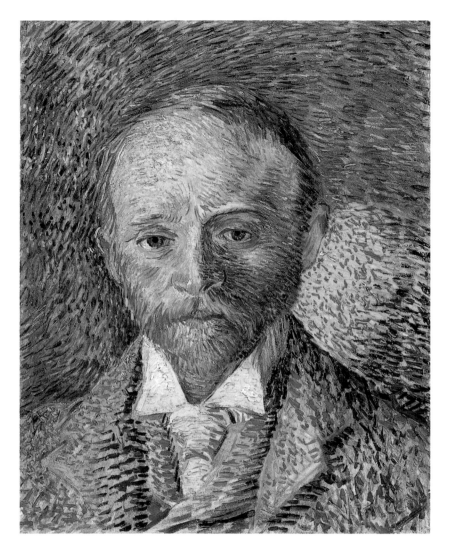

[25] *Portrait of Alexander Reid*
Oil on cardboard
Paris, Spring 1887
In this very small painting, the rhythmic
stippling and striations of brightly coloured
paint create a swirling effect. Because of the
remarkable physical resemblance between
Reid and Vincent, they were often mistaken
for twins. Indeed, for many years this painting
was assumed to be a self-portrait, until Reid's
son much later identified it as a portrait of his
father – Vincent's doppelgänger!

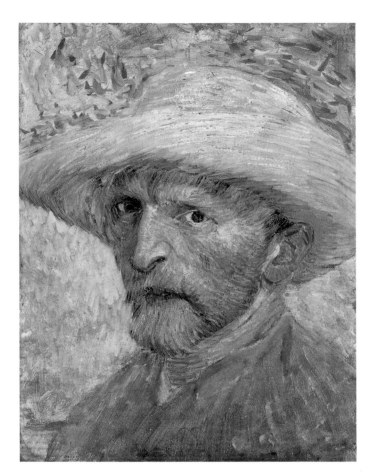

portraits of the Scotsman were created when Reid briefly
shared accommodation with the Van Gogh brothers at Theo's
rue Lepic apartment.

Vincent created approximately twenty-six of his thirty-
nine self-portraits in Paris. This high number was primarily
due to the lack of affordable models in the capital, but rather
than constraining his artistic development, this afforded
him a certain opportunity – by painting his own features he
could experiment without the potential distractions caused
by a model's presence. Some of the self-portraits were highly
precise, exploring pointillist methods, while others were
freely painted [26].

In Montmartre, Vincent met his artist friends at the Café du Tambourin, whose proprietress was Agostina Segatori (1841–1910). Of Italian origin, she had previously worked as an artist's model, and due to her striking appearance, she was much sought after by some of the leading painters working in Paris at the time. It was in the eccentric setting of her café, with its theatrical décor, that Vincent painted her portrait [27]. And the pair had a brief affair: 'I still feel affection for her and I hope she still feels some for me' (572).

In another portrait of Segatori, her glamorous appearance has been daringly stylized in a schematic fashion [28]. Thus, the painting resembles a decorative design. Vincent's inspiration may have been the popular posters that he would have seen in

[27] *Agostina Segatori Sitting in the Café du Tambourin*
Paris, February-March 1887
Agostina's distant, melancholic gaze and pale complexion contrast with her exotic costume. Despite the café's bizarre interior, complete with its tambourine-inspired tables and stools, Vincent chose to exhibit a selection of his Japanese prints there; one of these appears on the far right of Agostina. His gifts to her of small flower still-lifes formed part of the café's permanent decoration. These paintings were part of his ongoing experiments with pure colour.

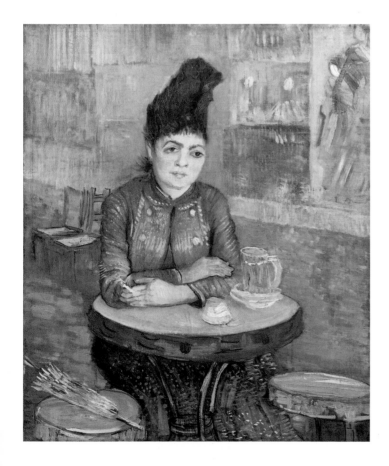

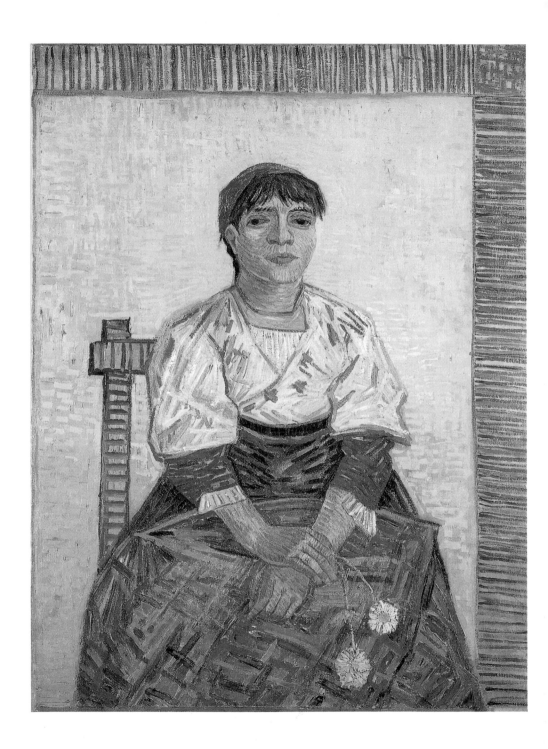

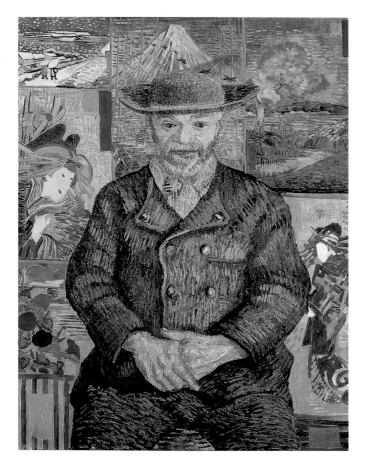

Montmartre – and in her café, where regular cabarets took
place. During his stay in Paris, he became convinced of the
importance of using bright, complementary colours: 'What
people want in art nowadays has to be very lively, with strong
colour, very intense' (574). He began, therefore, to study how
portraits could display these characteristics. One of Vincent's
three portraits of Julien François Tanguy (1825–1894), a
supplier of art materials and dealer in paintings and Japanese
prints, provides a spectacular example of his original use of
colour in portrait painting [29].

Vincent's last Parisian self-portrait, painted just before
he left for Provence, is a summation of all he had learned

during his two-year stay in the capital [30]. He used impressionist brushwork to depict his hair, pointillist dots and lines on his jacket, and created an harmonious effect by means of complementary colours – primarily gold and blue. Despite the light colour scheme and his confident stance, his eyes are dark and impassive, providing the only hint of his physical and mental exhaustion at the time of the painting's completion.

Indeed, Vincent had become extremely depressed, plagued by feelings of hopelessness and despair. Clearly this was an ominous prelude to the psychotic attacks that he was to experience a year later: 'In any event, when I left Paris very, very upset, quite ill and almost an alcoholic through overdoing it, while my strength was abandoning me' (695). Furthermore, life with Theo was proving increasingly difficult, mostly due to Vincent's irascible and argumentative tendencies. A total change of location, he felt, might reinvigorate him, and he had repeatedly expressed a desire to work in the south of France – where, unfortunately, he knew no one. Yet Vincent, 'the traveller', perhaps because of his pressing mental and physical problems, craved the sunshine, bright colours and pure light that he was sure Provence would provide.

[30] *Self-Portrait as a Painter*
Paris, early 1888
Describing this painting to his youngest sister Wil (Willemien van Gogh, 1862–1941), Vincent stressed that, when creating a self-portrait, an artist should attempt – intuitively – to produce an image that is psychologically revealing. But he acknowledged the difficulties of achieving this successfully: 'and it isn't easy to paint oneself – in any event *something different* from a photograph?....and one seeks a deeper likeness than that of the photographer' (626).

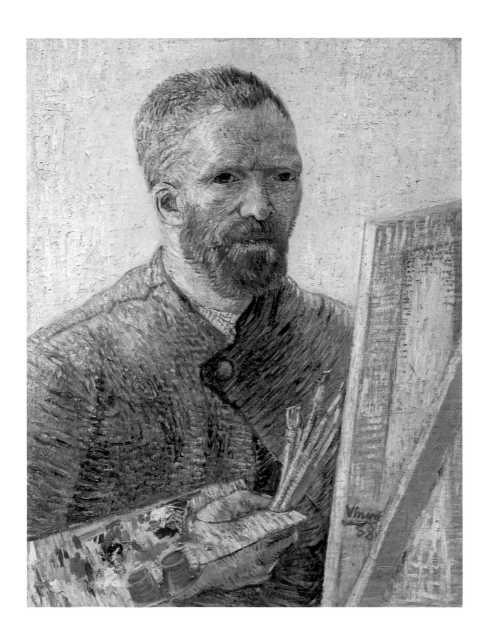

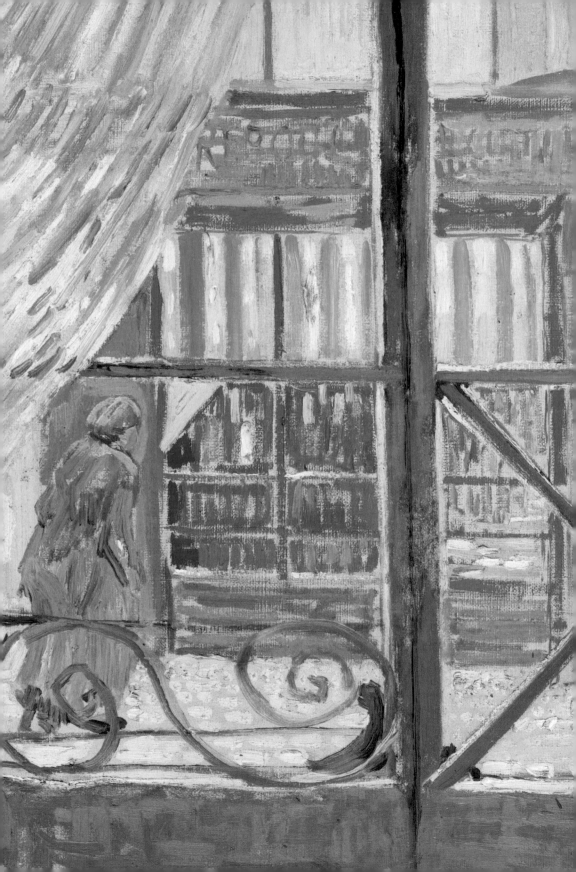

CHAPTER 3

Arles

'But what I hope to achieve is a good portrait'

On Saturday 19 February 1888, Vincent boarded the overnight train bound for the south of France. Leaving the mist and rain of Paris behind, he hoped to discover a warm environment that would help him regain his health – a climate with 'even more colour and even more sun' (574). His destination was the Provençal town of Arles, situated at the mouth of the river Rhône. As the train approached Provence, he was intrigued by the rolling hills and olive groves; a landscape completely new to him, but one that he was to immortalize. Gradually, however, the sky became overcast, and eventually heavy snow began to cover fields, trees and farmhouses. When he arrived in Arles, instead of his predicted 'land of the *blue* tones and gay colours' (569), the town and the surrounding countryside were smothered by deep snow.

Arriving late on Sunday 20 February, Vincent immediately booked a room in the Hotel-Restaurant Carrel, at 30 rue Amédée-Pichot. Overnight there were further heavy showers of sleet and snow, forcing Vincent to stay indoors the next morning. It was not until a welcome thaw occurred that he

PAGE 52

[31] *A Pork-Butcher's Shop seen from a Window* (detail)
Arles, February 1888
A network of interlocking geometric forms reveals the relationship between interior and exterior space. The composition is constructed of brightly coloured flat planes: a dominant foreground screen of wrought-iron window frames, and beyond, the counterpoint of the shop's façade. The woman hurrying by is a portent of the portraits Vincent was to paint later in Arles.

[32] *Snowy Landscape with Arles in the Background*
Arles, February 1888
Snow is rare in Provence, and the local newspaper reported deep drifts around the town. This image's sense of space is accentuated by the glimpse of Arles on the distant horizon. Muted colours and the snow-laden sky reveal the chill that Vincent had endured painting out-of-doors. And he was reminded of his favourite Japanese prints depicting snow scenes.

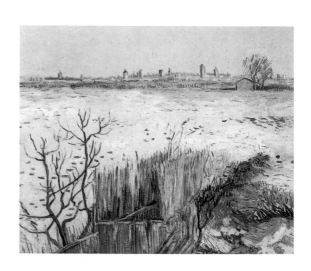

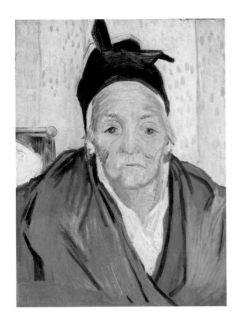

was able to explore the town and its surroundings. In the rural
hinterland, he painted two snow scenes: one in particular
displays the depth of the snow in the fields [32].

Due to the persistent cold weather, however, Vincent decided
to postpone further painting expeditions out-of-doors.
Instead, he set up his easel in the warmth of the residents'
dining room in order to paint the adjoining street and the
shopfronts facing the hotel. The painting – a 'townscape' and
one of Vincent's most daring compositions – combines the
metal framework of the dining room's windows, the icy street
and the façade of the butcher's shop opposite [31].

Prior to his departure for Provence, Vincent had expressed
the hope that, when established there, and immersed in
the area's clear, southern light, he would be able to 'paint a
good portrait' (574). It is significant that Vincent, always the
perfectionist, did not write 'another' good portrait. Despite
all of the memorable portraits that he produced in the
Netherlands, Belgium and Paris, for him a truly successful
portrait still seemed elusive. His earliest Arles portrait was of
the widowed mother-in-law of his landlord [33]. She agreed to

[34] *Portrait of a Man*
Arles, December 1888
Vincent soon discovered models that seemed to epitomize the male inhabitants of the town. This man, possibly encountered in a local café-bar, has a disquieting, quizzical gaze that Vincent no doubt found compelling. The portrait is essentially a 'tronie' in the style of Hals.

[35] *Mousmé*
Arles, July 1888
This portrait has a gentle, decorative quality, reflecting Vincent's wish that some of his paintings should have a soothing effect: 'And in a painting I'd like to say something consoling, like a piece of music' (673). Mousmé is holding a spray of oleander blooms, symbols of everlasting love; it is possible that Vincent was alluding to Rembrandt's famous portrayals of the goddess Flora.

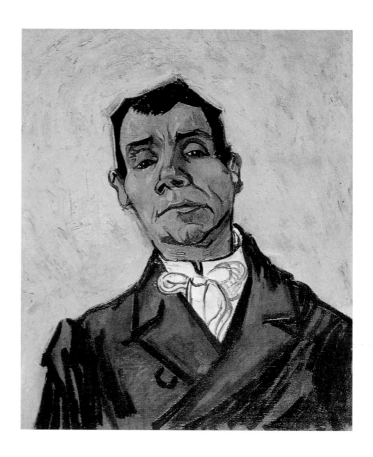

pose for Vincent in the privacy of one of the hotel's bedrooms; she was sixty-eight when she became, somewhat reticently, an artist's model. As with many of Vincent's portraits of elderly women, in this painting he was able to express her vulnerability and underlying sadness.

When the weather improved, Vincent was able to explore the local streets and cafés, looking for models to paint. His early weeks in Arles resulted in powerful character studies – portraits of anonymous people he encountered who seemed to him to have stepped out of his favourite realist novels [34]. Urban life in Arles was also to provide him with attractive female models to paint. In nineteenth-century France, the women of Arles were renowned for their gracefulness, and when writing to Theo, Vincent confirmed

that this legend seemed to hold true: 'The women really are beautiful here' (578). When he met a lovely adolescent girl, he gained permission to paint her portrait [35]. As he had been reading the novel *Madame Chrysanthème* by Pierre Loti (1850–1923), in which 'mousmé' was the term used for a young Japanese woman, Vincent decided to use this name as the

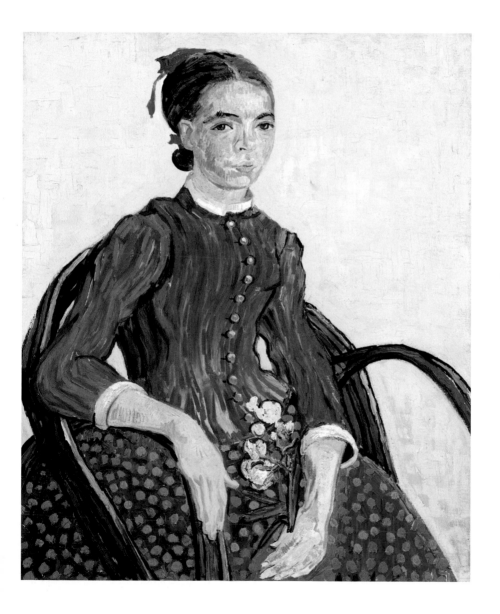

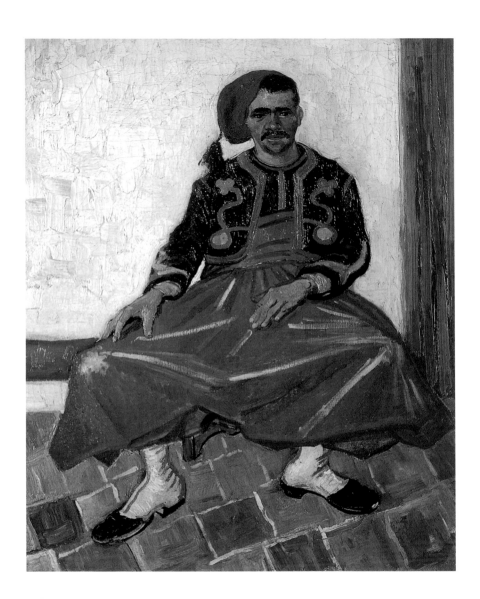

[36] *The Seated Zouave*
Arles, June 1888
Vincent's admiration for colourful
costumes is once again evident in
this vivid portrait. The soldier's
flamboyant uniform displays
features that seem to echo the
traditional Japanese costumes
that Vincent admired in his
collection of woodblock prints.

portrait's title. To him the girl represented a 'mousmé' living in Provence – another example of Vincent perceiving his models in terms of contemporary literature. Over and above this literary context, the portrait itself is one of his most memorable works.

Vincent believed that by painting portraits of ordinary people of all ages, he would be able to portray a segment of society much as a novelist could: 'the painting of humanity, let's rather say of a whole republic, through the simple medium of the portrait' (651). In Arles, his choice of models widened to include, for example, a gardener, a postal official, a doctor, a mother and child, a baby, a schoolboy, a teenager and some soldiers. The latter belonged to the third regiment of the Zouaves, a body of light infantry whose barracks were in Arles. Their colourful uniforms reflected the regiment's Algerian origin, and Vincent created a number of portraits showing their exotic appearance [36, 37].

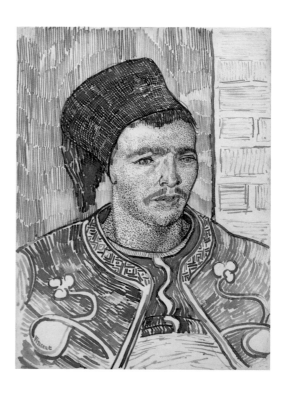

[37] *The Zouave*
Arles, July–August 1888
Pencil, reed pen, quill pen, and brown ink on woven paper
Vincent devised a vocabulary of ink marks – dots, lines and hatching – to depict a wide range of textures. In a highly original manner, flesh, fabric and stonework have been suggested by complex patterns: 'I've written it down in shorthand' (260).

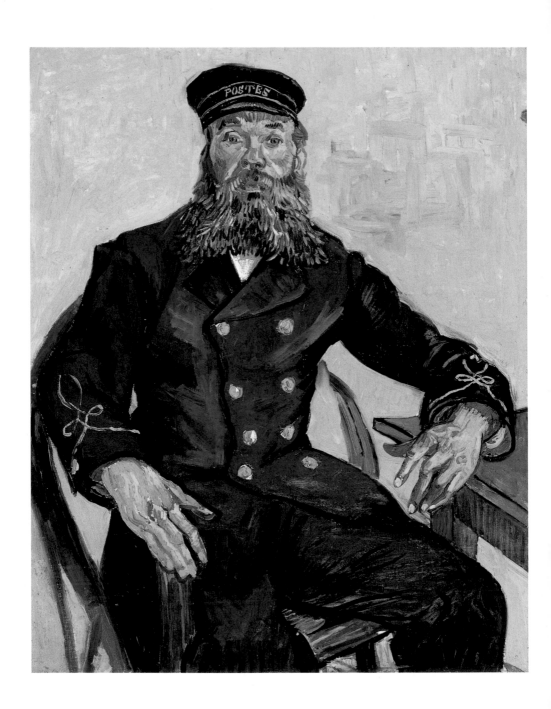

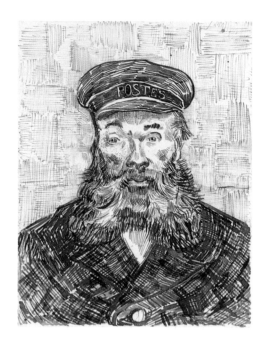

[38] *Portrait of the Postal Officer, Joseph Roulin*
Arles, early August 1888
Although Vincent became very familiar with his friend's strong personality during their regular discussions in cafés, he questioned whether he could convey his character adequately when creating his portrait: 'I don't know if I'll be able to paint the postman *as I feel him*' (663). Vincent resolved to portray him as a staunch republican and benevolent pillar of society.

[39] *Portrait of the Postal Officer, Joseph Roulin*
Pen and ink
Arles, August 1888
Reminiscent of an etching, the complex ink lines coalesce to recreate Roulin's powerful yet kindly stare. Vincent's drawing conveys his friend's strength of character and reliability.

As we have seen, Vincent thought that a portrait painter should empathize with his model's personality, thereby producing a psychologically astute image: 'Ah, the portrait – the portrait with the model's thoughts, his soul' (673). But he realized that a painter could only ever speculate, by an imaginative leap, as to his sitter's 'soul' or innermost nature – except when creating a self-portrait. That said, many of Vincent's Arles portraits do reveal his ability to depict his model's character – as he perceived it – in an expressive manner. His series of portraits of Joseph Roulin (1841–1903) displays Vincent's sensitivity to his models' personalities [38, 39]. Roulin worked at Arles railway station, where he was in charge of mail distribution between Arles and Paris. He was one of Vincent's closest friends in the town, and helped him greatly during his periods of illness. This friendship led Vincent to create portraits of all members of the Frenchman's family: his two sons [40, 41]; his wife; and his baby daughter [42, 43]. In this suite of portraits he hoped to portray a loving family made up of unpretentious individuals.

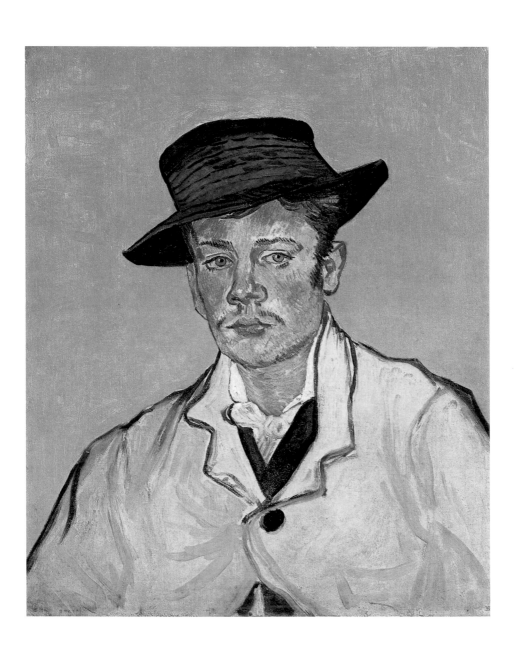

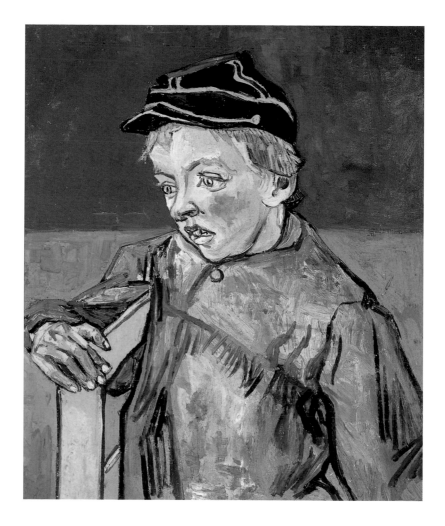

[40] *Portrait of Armand Roulin*
Arles, November–December 1888
Armand (1871–1945) was the Roulins'
elder son, seventeen years of age
when he posed for this portrait.
Probably influenced by Bernard's
self-portrait [50], Vincent employed
thin paint and gently flowing
lines to create an image of elegant
simplicity, matching Armand's
fashionable attire. Vincent's
restrained portrayal of the young
man conveys his thoughtful
demeanour.

[41] *Portrait of Camille Roulin*
(*'The Schoolboy'*)
Arles, November–December 1888
Camille (1877–1922) was the Roulins'
younger son. This is the most colourful
of the three portraits that Vincent
painted of the eleven-year-old boy. The
distinctive background is composed
of two coloured bands, red and
orange, the latter interacting with
the complementary blue of Camille's
smock. His hand, the chair back and the
braiding on his cap have been carefully
articulated in a graphic manner.

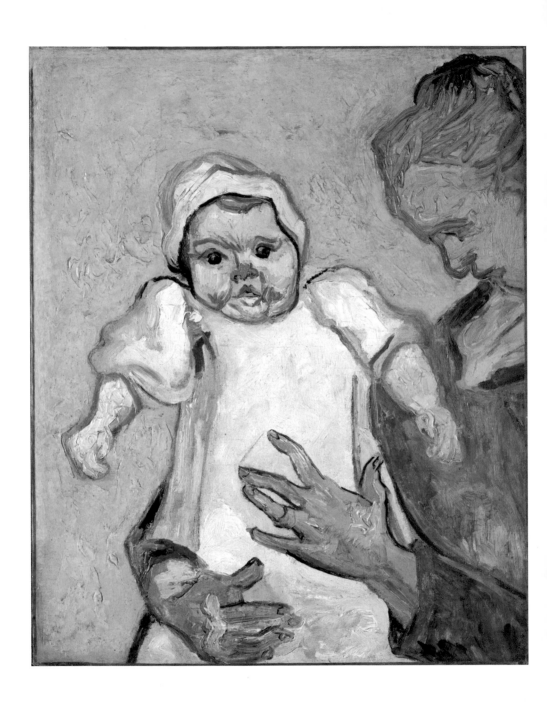

[42] *Madame Roulin with her Baby*
Arles, November–December 1888
Vincent painted two portraits
of Madame Augustine Roulin
(1851–1930) and her four-month-old
daughter Marcelle (1888–1980). In this
version, the baby is centrally placed,
her mother attempting to hold her
still. Given the restlessness of the
baby, Vincent resorted to painting
the portrait very quickly using a
thickly laden brush and palette knife.

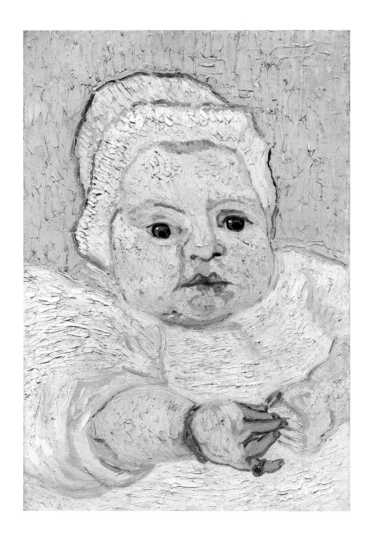

[43] *The Baby Marcelle Roulin*
Arles, December 1888
Vincent viewed babies as symbols
of burgeoning life. His portrait of
Marcelle avoids the prettiness of
Impressionist paintings of the same
subject matter; rather he sought to
evoke the mystery of regeneration.

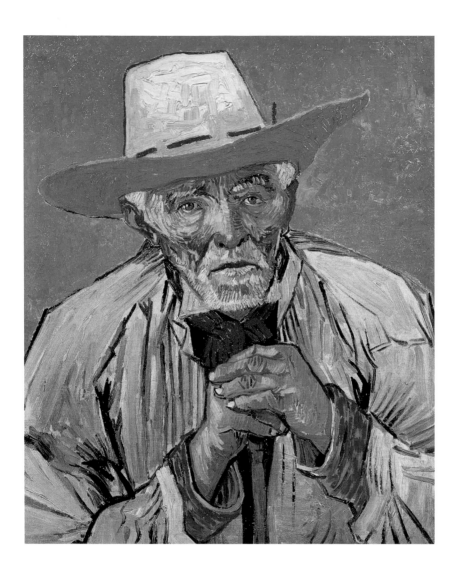

[44] *Portrait of Patience Escalier ('The Peasant')*

Arles, August 1888

A former oxherd, Escalier was working as a gardener when the artist met him. Vincent increased the intensity of his colours to suggest 'the very furnace of harvest time' (663). He no longer tried to render exactly what he saw: 'I use colour more arbitrarily in order to express myself forcefully' (663).

Vincent's main reason for settling in Provence was to experience a greater intensity of colour, and he found the brightness almost overwhelming: 'being surrounded by colour like this is quite new to me, and excites me extraordinarily' (689). His portrait of a gardener, Patience Escalier (1816–1889), is evidence of his ability to apply bright colour, not only to depict his model's character, but also to suggest the intense heat of midday [44]. In contrast, his ink drawing of the same model is sombre and pensive [45].

Vincent's penchant for literary allusions in his portraits re-emerged in September 1888 when he painted portraits of two friends. He perceived Eugène Boch (1855–1941), with his 'refined and nervous head' (678), as being the epitome of 'The Poet' [46]. His portrait of the handsome soldier, Paul-Eugène Milliet (1863–1943), he entitled 'The Lover' [47].

[45] *Portrait of Patience Escalier*
Pencil, pen and ink
Arles, August 1888
The gardener's sunburnt face and soulful eyes are evidence of his hardworking existence. The background, created by clusters of ink dots, is a highly original application of pointillism by graphic means. Vincent saw his portraits of the old peasant as 'absolutely a continuation of certain studies of heads done in Holland' (665).

'Ah well, thanks to him – at last I have a first sketch of that painting I've been dreaming about for a long time – the poet' (673)

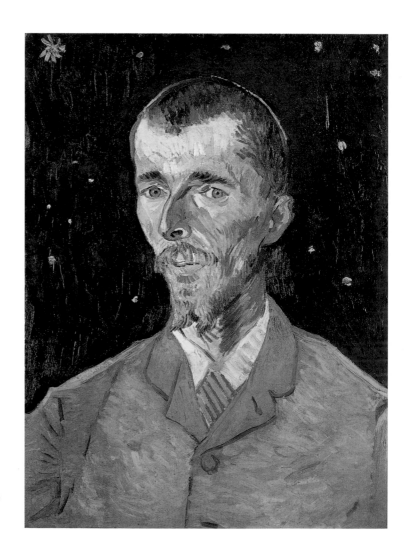

[46] *Portrait of Eugène Boch ('The Poet')*
Arles, September 1888
Vincent regarded Boch, a Belgian artist, as the ideal model for his long-contemplated portrait of an archetypal poet. This portrait is therefore a rare example of Vincent envisaging a portrait before he had encountered his model.

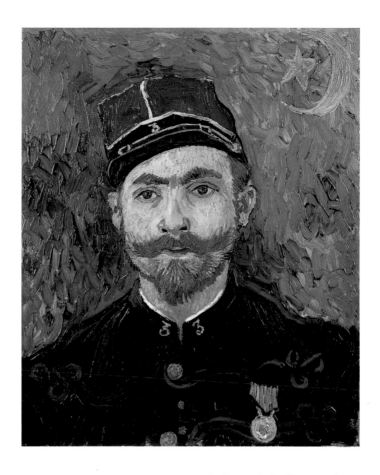

[47] *Portrait of Milliet, Second Lieutenant of the Zouaves ('The Lover')*
Arles, late September 1888
Vincent and the young soldier became firm friends. They exchanged books, discussed literature, and Milliet even received drawing lessons from the Dutchman. Vincent, impressed by Milliet's good looks and easy-going love affairs, cast him in the guise of 'The Lover' when he painted him, resplendent in his Zouave uniform.

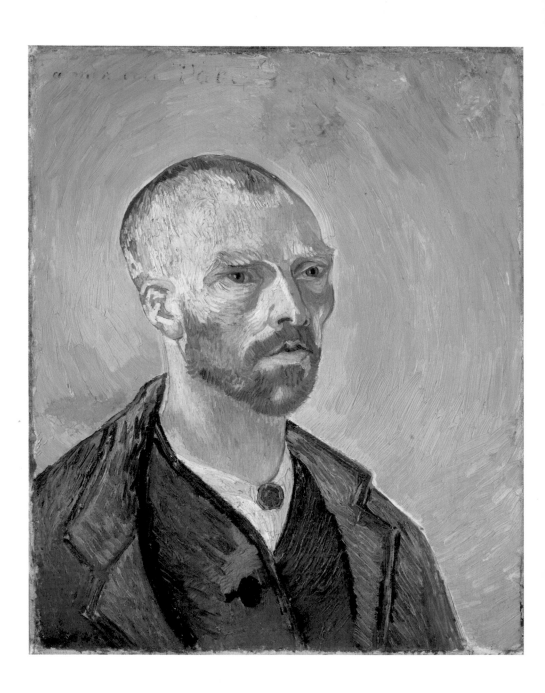

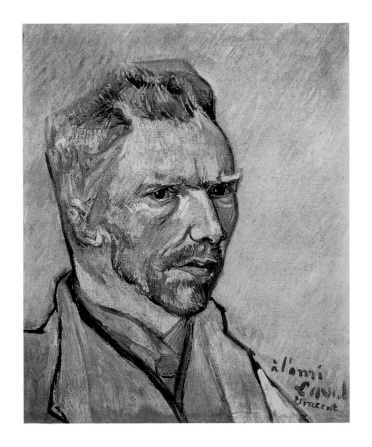

[48] *Self-Portrait*
(Dedicated to Paul Gauguin)
Arles, September 1888
Vincent exaggerated his facial
features in this self-portrait in
order to achieve a spiritual mood.
His shaved head, he believed, gave
him the appearance of a 'bonze, a
simple worshipper of the eternal
Buddha' (697). Acknowledging the
Japanese origin of 'surimonos', he
even altered the shape of his eyes:
'I've *slightly* slanted the eyes in the
Japanese manner' (697).

[49] *Self-Portrait (Dedicated
to Charles Laval, 1862–1894)*
Arles, November–December 1888
This 'surimonos' self-portrait is one
of Vincent's most elegant paintings.
Nothing is over-exaggerated, and
the painting's surface is free from
extraneous patterning and impasto.
The directness of Vincent's gaze
has been achieved by a seemingly
effortless technique, and the yellow
of his jacket harmonizes seamlessly
with the green background.

Thus, although his models were very familiar to him, Vincent
sought to classify them as romantic 'types'.

His artist friends, who were working in Brittany, proposed
that they should exchange self-portraits, in order to promote
artistic collaboration. Vincent contributed two paintings to
the scheme [48, 49]. Émile Bernard hoped that the exchange
of self-portraits would promote a deeper understanding of
new styles among like-minded painters – for example, folk
art, symbolism, Japanese graphic art, and 'cloisonnism'.
Vincent was certainly influenced by the self-portraits
he received from Laval, Gauguin and Bernard as part of
this collaborative venture. Bernard, inspired by Japanese
'surimonos' – woodblock prints and drawings exchanged
by artists as gifts – had promoted the idea. Vincent was

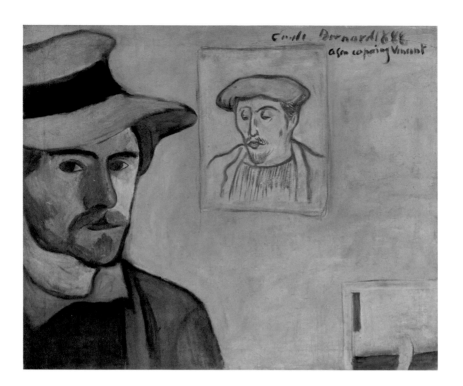

[50] *Self-Portrait (Dedicated to Vincent van Gogh: 'to my pal Vincent') | Émile Bernard*
Pont-Aven, 1888
Of the self-portraits sent to him as part of the 'surimonos' exchange scheme, Bernard's asymmetrical composition was Vincent's favourite. In particular, he admired his young friend's use of elegant flowing lines: 'it's as stylish as real, real Manet' (697).

greatly impressed by his young friend's self-portrait when it arrived in Arles [50].

In September 1888, Vincent left the café-restaurant where he was living and moved to a disused, semi-derelict property – the famous 'Yellow House'. Using what little funds he had, he organized its renovation, refurbishing two bedrooms, two spare rooms, a studio and a kitchen. His aim was to create, not only a tastefully decorated 'artist's house', but also a place where a few visiting artists could live and work [51]. He furnished his new home with traditional furniture, including 'straw-bottomed chairs' (678). One of these he painted as both a still-life and as a virtual self-portrait – his vacant chair symbolizing his ongoing existence in the Yellow House [52].

Although he hardly knew him, Vincent invited Paul
Gauguin (1848–1903) to live and work with him in Arles; in
this way he hoped that his dream of a brotherhood of artists
could be firmly established. Reluctantly, Gauguin accepted,
arriving on 23 October 1888. Vincent believed that Gauguin
should be the leader of the new studio. But while Vincent
was right to regard Gauguin as a great painter, he was wrong
to believe himself artistically inferior [53, 54]. Gauguin
advocated working from imagination, whereas Vincent

[51] *The Yellow House*
Arles, September 1888
Vincent gave a vivid account of his
new home to his sister Wil: 'I live
in a little yellow house with green
door and shutters, whitewashed
inside – on the white walls – very
brightly coloured Japanese drawings
– red tiles on the floor – the house in
the full sun – and a bright blue sky
above it...' (626).

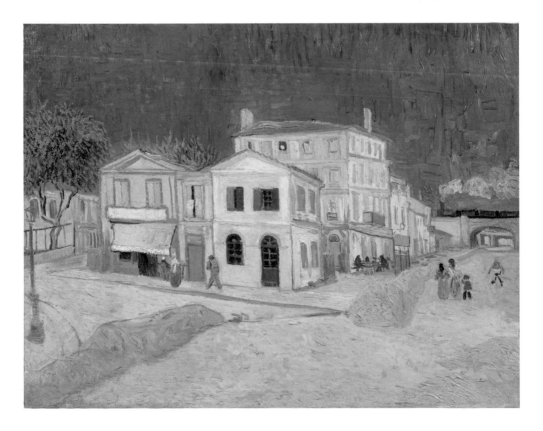

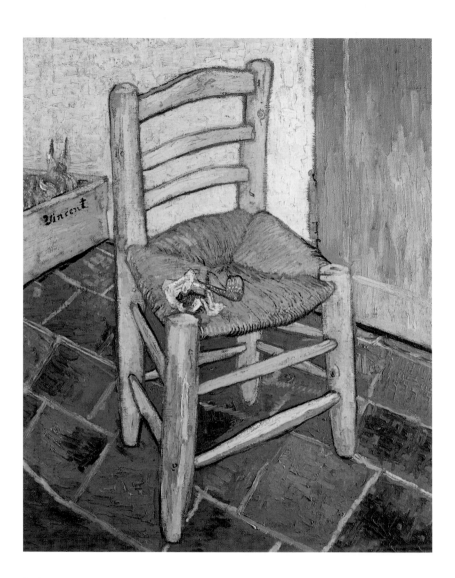

[52] *Vincent's Chair with his Pipe*
Arles, December 1888
It is remarkable that, in painting
such a humble artefact, Vincent
gave it such a monumental presence
on his canvas. However, with the
depiction of his own possessions
on the chair – his pipe and tobacco
pouch – Vincent was also able to
suggest his everyday life.

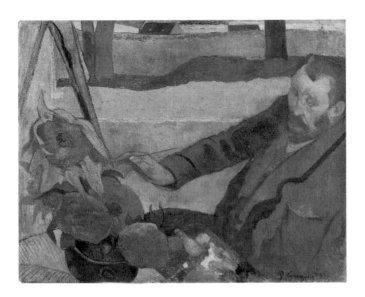

[53] *Van Gogh Painting Sunflowers | Paul Gauguin*
Oil on burlap
Arles, October–November 1888
During their nine weeks living together, each artist painted a portrait of his studio companion. Although Gauguin's work is typically imaginative, Vincent, ominously, felt that the portrait made him look mad. Vincent's initial deference to his less intelligent – but less excitable – colleague soon gave way to prolonged arguments about art and literature.

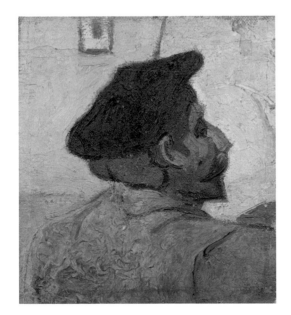

[54] *Portrait of Gauguin*
Oil on burlap
Arles, October–December 1888
In the flat areas of pure colour, and the outlines used to emphasize his model's distinctive profile, Vincent's portrait reveals the influence of the paintings Gauguin completed in Arles. The juxtaposition of red and green – complementary colours – underlines the portrait's decorative qualities.

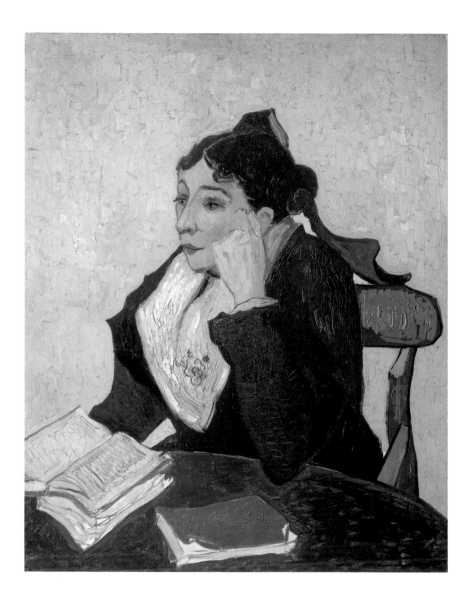

[55] *L'Arlésienne: Madame Ginoux with Books*
Arles, November 1888 (or May 1889)
Although he continued to paint his portraits
from life, Vincent sometimes stylized his
models' appearances according to his artistic
preoccupations. Thus Madame Ginoux (1848–1911)
has been depicted in the manner of Japanese
graphic art, one of Vincent's major interests.
In particular, his treatment of the pure yellow
background owes much to woodblock prints.

remained staunchly committed to painting portraits from the live model [55].

By December 1888, relations between Gauguin and Vincent had deteriorated, with Gauguin increasingly alarmed by the Dutchman's mood swings and manic behaviour. On Sunday 23 December, Vincent suffered a major psychotic attack during which he cut off his left ear. The police were called, and Vincent was hospitalized immediately. He was treated by Dr Félix Rey (1867–1932), and on leaving hospital, Vincent painted a portrait of the young doctor and presented it to him as a gift [56]. Gauguin meanwhile had returned to Paris. Vincent continued to visit the hospital regularly, where Dr Rey replaced his bandages. In this wounded state, he painted two extraordinarily honest self-portraits [57, 58].

[56] *Portrait of Doctor Félix Rey*
Arles, January 1889
After leaving hospital, Vincent quickly recommenced painting. He was pleasantly surprised at being able to complete Dr Rey's portrait successfully: 'And [I] haven't yet altogether lost my equilibrium as a painter' (740). But Dr Rey's mother disliked the portrait so much that it was banished to the hen house. Rediscovered in 1901, it now hangs in Moscow's Pushkin Museum.

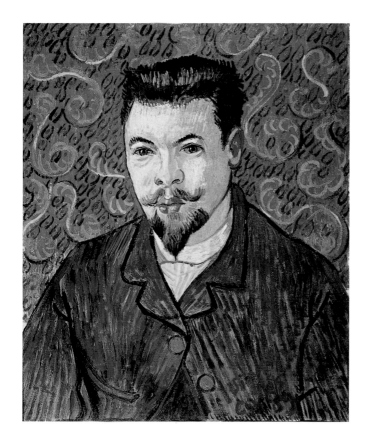

[57] *Self-Portrait with Pipe and Bandaged Ear*
Arles, January 1889
Vincent portrayed himself in a calm, resigned state after the turmoil of his psychotic attack. Above all, the portrait is a truthful record of his remarkable resilience. Vincent often wrote that smoking his pipe gave him comfort in times of stress. His use of complementary colours had never before been so explicit as in this portrait.

[58] *Self-Portrait with Bandaged Ear*
Arles, January 1889
The easel behind Vincent and the Japanese print on the whitewashed wall give a glimpse of his studio in the Yellow House. Vincent seems reconciled to his desperate situation; no other great artist has ever painted himself so dispassionately after such horrific self-mutilation. Psychiatrists now believe that self-harm is a drastic attempt by a mentally ill person to release unbearable tensions and distress.

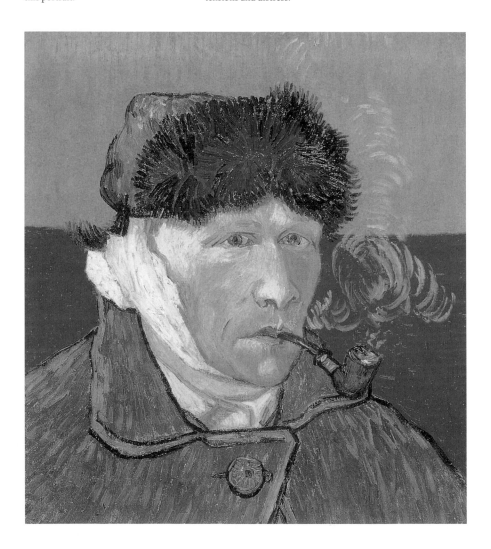

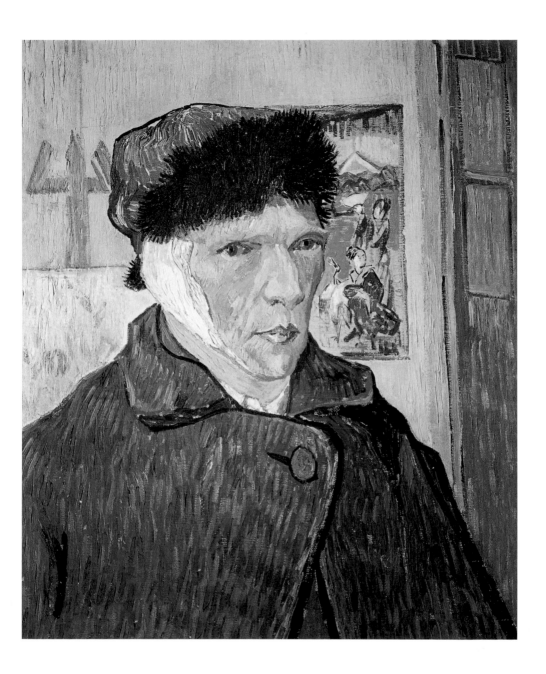

These are deeply disquieting images, haunting records of human suffering due to mental illness. Yet, remarkably, both portraits are completely free from self-pity or angst. Unfortunately, he was to suffer more attacks towards the end of his stay in Arles: 'In all I've had 4 big crises in which I hadn't the slightest idea of what I said, wanted, did' (764). Evidently his mental condition was becoming more severe in nature.

Before he left Arles, during a period of remission, Vincent painted five almost identical canvases of Madame Roulin. But instead of painting her in a realistic fashion, he portrayed her as 'La Berceuse' – an archetypal mother rocking her child's cradle [59]. Although inspired by popular lithographs, Vincent's painting achieves an almost religious intensity, Madame Roulin like an icon dedicated to motherhood.

During his fifteen months in Arles, Vincent produced around two hundred paintings and one hundred drawings and watercolours, and wrote over two hundred letters – a phenomenal output, but one which took its toll on his mental health.

[59] 'La Berceuse' (Madame Augustine Roulin)
Arles, December 1888–January 1889
In this work, Vincent adopted a style pioneered by his two friends, Bernard and Anquetin – 'cloisonnism'. Inspired by the prints and enamelled ceramics of Japan, and European stained glass, this technique employed dark lines to separate planes of bright colour. Vincent outlined his model's costume and chair in order to give the portrait a symbolic resonance – 'a lullaby with colour' (740).

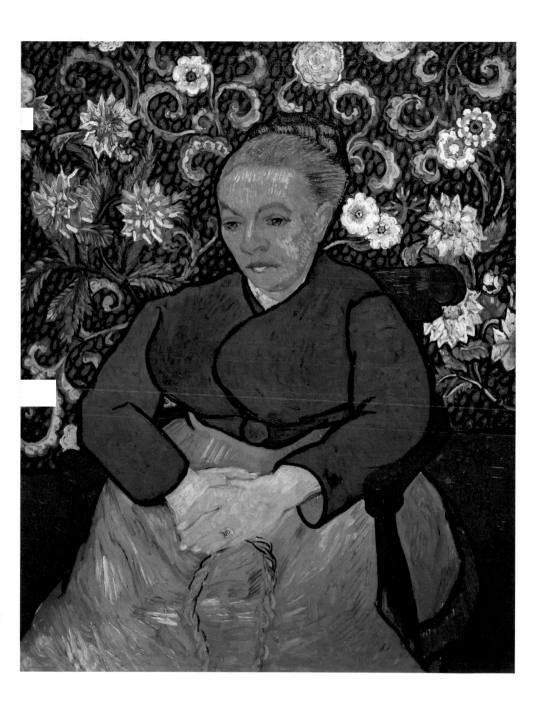

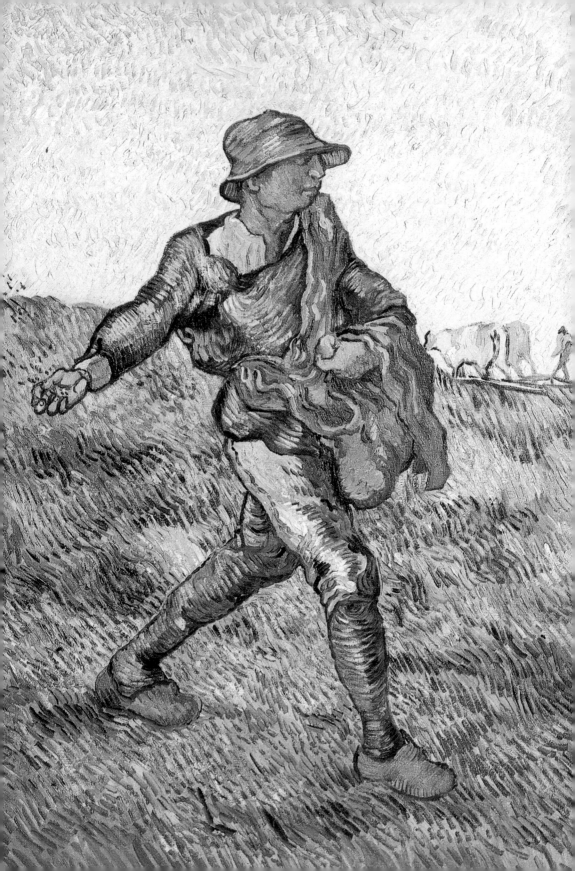

CHAPTER 4

Saint-Rémy-de-Provence

'And little by little I can come to consider madness as being an illness like any other'

After his series of psychotic attacks and subsequent hospitalizations, Vincent felt that he could no longer care for himself in Arles. Furthermore, a group of citizens, afraid of his erratic behaviour, had petitioned the local police for his removal from their midst. Vincent decided, therefore, that he should admit himself as a voluntary patient to the asylum of Saint-Paul de Mausole in Saint-Rémy-de-Provence, about fifteen miles northeast of Arles. Although a daunting prospect, he realized that this self-imposed loss of liberty was inevitable given the alarming deterioration in his health.

On Wednesday 8 May 1889, Vincent left Arles by train for the short journey to Saint-Rémy. He travelled under the supervision of Reverend (Louis) Frédéric Salles (1841–1897), a parson of the Reformed Protestant Church in Arles, whom Vincent had befriended much earlier. On arrival at the asylum, Vincent explained to the director, Dr Théophile-Zacherie-Auguste Peyron (1827–1895), that he no longer possessed the strength to live independently. Although his new patient now seemed stable, Dr Peyron recorded Vincent's recent psychotic attacks in the admissions' register in bleak terms: acute mania with hallucinations of sight and hearing that had caused him to mutilate himself by cutting off one of his ears.

Given the episodic nature of Vincent's attacks, if not their duration, Dr Peyron speculated that epilepsy could be a contributing factor to his psychological decline. However, as in the nineteenth century epilepsy was purely a generic term covering a wide range of mental disorders, most psychiatrists today, including the current director of the Saint-Paul hospital for the mentally ill, believe that Vincent was suffering from the later stages of manic depression (bipolar affective disorder). This would account, they assume, for his

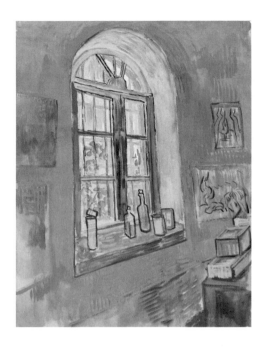
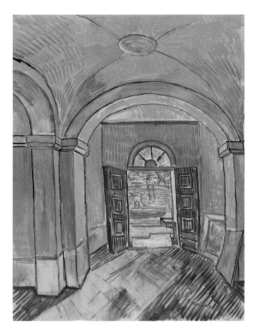

series of increasingly severe manic episodes, followed by calm periods interspersed with bouts of depression; his earlier attack in 1880, during his missionary work in the Borinage, was thus a harbinger of worse to come in Provence. Although this illness has been effectively managed by medication since the 1960s, during Vincent's time at the asylum only quiet and cold baths were seen as potential remedies for manic attacks.

As Vincent admitted to having suicidal thoughts, Dr Peyron decided that, initially, he should be restricted to his own bedroom in the men's ward. As there were thirty empty rooms in this wing of the asylum, he also assigned one of these to Vincent for use as a studio [60]. Later, when Vincent seemed to have gained more composure, he was allowed to walk out through the asylum's formal doorway into the large, overgrown garden where he was to paint some of his most beautiful studies of flowers and trees [61].

Vincent was confident that painting would aid his recovery: 'I believe that all my faculties for work will come back to me quite quickly' (772). But despite his optimism regarding

[60] *Window in the Studio*
Black chalk and gouache on pink Ingres paper
Saint-Rémy, May–June 1889
In between his frequent manic attacks, Vincent was able to work calmly in his studio. But the barred window in this image is a poignant reminder of his voluntary incarceration.

[61] *Vestibule of the Asylum*
Black chalk and gouache on pink Ingres paper
Saint-Rémy, May–June 1889
The asylum's formal doorway, located at the end of a long corridor, became a symbol of limited liberty for Vincent. Because the garden was enclosed by a high outer wall, he was permitted to paint out-of-doors unattended between attacks.

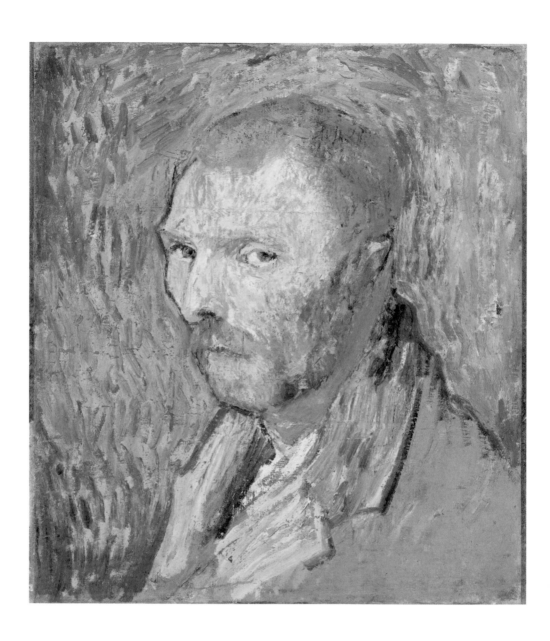

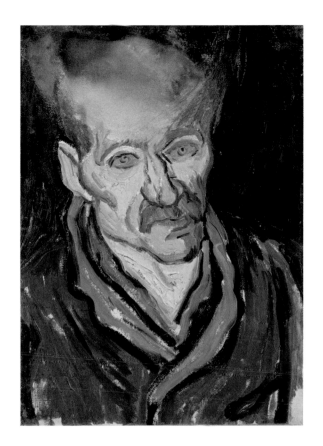

[62] *Self-Portrait*
Saint-Rémy, September 1889
By applying techniques he had
previously perfected in the
Netherlands – swift brushstrokes
of thick, wet-on-wet paint – Vincent
achieved an expressive image of his
features. Although the Provençal
colours are bright, the overall
mood of this self-portrait is one of
unease. Understandably, he feared
future attacks and even impending
madness.

[63] *Portrait of a Patient
in the Saint-Paul Asylum*
Saint-Rémy, October 1889
This character study is both
disturbing and compassionate.
The man's vacant, pale eyes seem
to suggest his troubled mental
state; the portrait possesses the
haunting quality that Vincent
hoped to achieve.

the beneficial effects of painting, his mental illness re-
emerged with full force. In July 1889, only five weeks after
his admission to the asylum, Vincent experienced a major
psychotic episode that lasted almost five weeks. When he
recovered, typically he had lost none of his intelligence and
determination to continue with his painting, especially
portraits of his fellow patients and self-portraits [62].

Vincent was impressed by the willingness of some
patients, despite their own illnesses, to help others in
distress. However, many displayed lethargy and despair,
characteristics that Vincent managed to evoke in his
paintings [63]. Indeed, he hoped that some of his most
perceptive portraits, like this example, would acquire a
ghostly, unsettling appearance in the future – 'would look

[64] *Self-Portrait*
Saint-Rémy, late August 1889
Despite the severity of Vincent's
illness, his remissions allowed him
to paint with great concentration
and determination. In this self-
portrait, he portrays himself,
perhaps defiantly, as a practising
artist, wearing a smock and
holding his palette and brushes.
He exudes a renewed confidence
and strength of purpose after a
particularly debilitating attack.
The dominant use of blue is offset
by the complementary gold.

[65] *Portrait of Trabuc, an*
Attendant at the Saint-Paul
Asylum
Saint-Rémy, September 1889
This is Vincent's 'studio copy' of
the now lost portrait from life. It
is extremely stylized, especially in
the serpentine lines used to suggest
the folds of Trabuc's jacket. His face,
with its penetrating gaze, is also
made up of a network of short lines.
Overall, the painting has a flame-
like quality, underscored by the pale,
parallel brushmarks that form the
background.

like apparitions to people a century later' (879). Furthermore,
the enigmatic self-portraits that Vincent painted in the
asylum seem to chart the mood swings that were a feature of
his illness. Fortunately, however, when free from depressive
symptoms, he was able to work in a positive, untroubled
manner [64].

He was permitted to paint for a short while beyond the
asylum walls, accompanied by the head attendant, Charles-
Elzéard Trabuc (1830–1896). Trabuc also escorted Vincent
on a few occasions when the artist returned to Arles to visit
friends. Vincent painted two portraits of Trabuc, one from
life and one as a studio copy; only the latter survives [65].

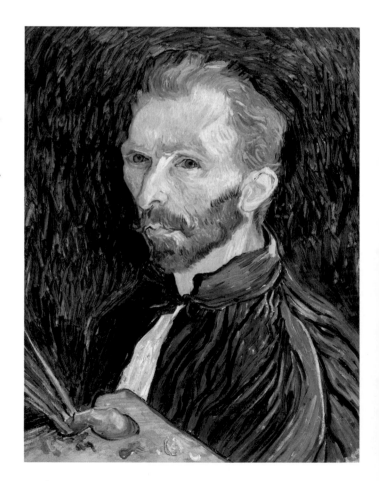

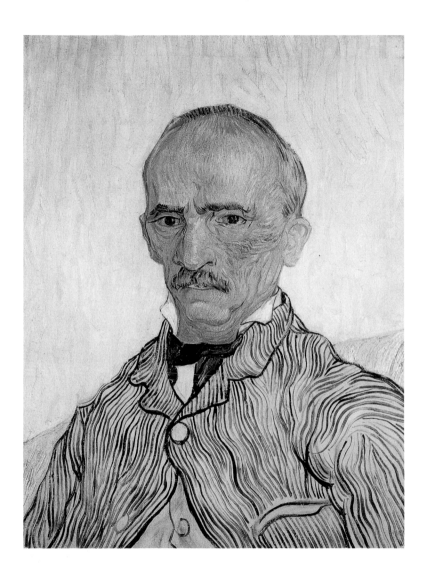

Vincent found Trabuc to be a kind, sympathetic individual, but saw in his pensive expression a person who had seen much suffering. His wife, Madame Jeanne Trabuc (1834–1903), also agreed to sit for Vincent [66]. His rather severe portrait highlighted her 'olive-tinged, suntanned complexion' (804). A much more cheerful painting of a young man was completed in the walled garden; this is one of Vincent's few portraits in which his model is smiling [67].

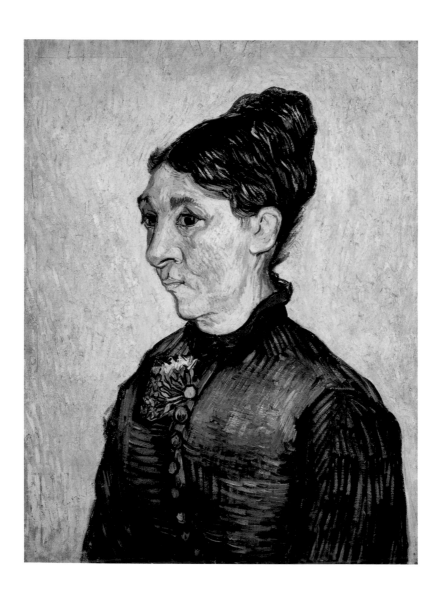

[66] *Portrait of Madame Trabuc*
Saint-Rémy, September 1889
Vincent painted two portraits of
Madame Jeanne Trabuc, her 'face
faded and tired' (804). The first work,
created from life and presented
as a gift to his model, is now lost.
The painting illustrated here was
Vincent's 'studio copy', a memento
of his initial insightful portrait.

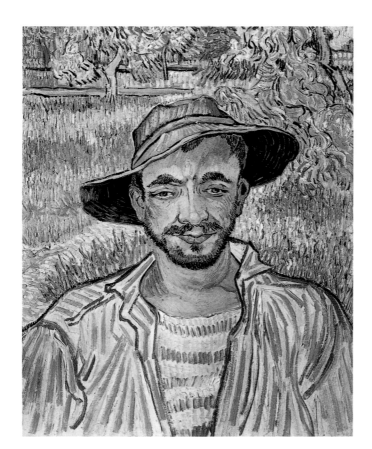

[67] *The Gardener
or Young Peasant*
Saint-Rémy, September 1889
Clearly Vincent was intrigued
by this young man's gently
mocking expression, which he
captured so well in his painting.

*'... a painted portrait is a
thing of feeling made with
love or respect for the being
represented'* (804)

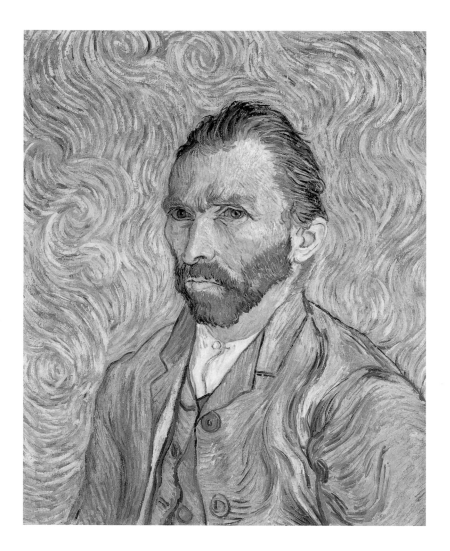

[68] *Self-Portrait*
Saint-Rémy, September 1889
This self-portrait – arguably Vincent's
finest – has a grandeur of conception
and technique worthy of Rembrandt
and Titian (Tiziano Vecellio, c. 1489–1576).
Unique to Van Gogh's painting, however,
is the tension achieved between precision
and a sense of flux. The latter quality is
most evident in the swirling lines – like
eddies of water – on the jacket and the
turbulent background. His face, by
contrast, is the still centre of the portrait.

In September 1889, despite his fragile mental state, Vincent produced two of his greatest self-portraits [68, 69]. The unpredictable nature of his illness, which periodically left him incapacitated or suicidal, meant that at times he could paint works of the highest quality. However, when he did not feel well enough to paint new subjects from life, he created replica versions of his previously completed portraits. Thus, he painted, from memory, a new portrait of Madame Ginoux, a friend from Arles – four versions of this portrait are known [70]. He also asked Theo to send him a copy of a lithograph he had made in The Hague – *Old Man in Sorrow* – so that he could create an oil painting based on the print [71].

[69] *Self-Portrait*
Saint-Rémy, September 1889
Vincent's psychotic attacks increased in frequency and severity during his time at Saint-Paul; yet between episodes he was able to work relatively calmly. This self-portrait – his last – was painted as a gift for his mother on her seventieth birthday. But his clean-shaven face projects a sense of unease and fearfulness – understandable given his desperate situation.

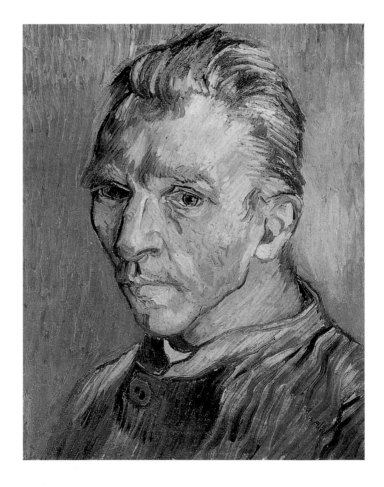

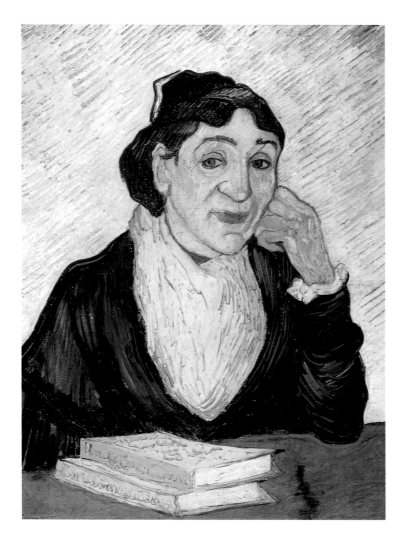

[70] *L'Arlésienne (Madame Ginoux)*
Saint-Rémy, February 1890
Madame Marie Ginoux and her
husband, Joseph-Michel Ginoux
(1836–1902), ran the Café de la Gare
where Vincent stayed during the
summer of 1888, before moving to the
Yellow House. On the table are two
of Vincent's favourite literary works:
Uncle Tom's Cabin, by Harriet Beecher
Stowe (1811–1896), and *The Christmas
Tales*, by Charles Dickens (1812–1870).

[71] *Old Man in Sorrow
(on the Threshold of Eternity)*
Saint-Rémy, April–May 1890
In 1882, while living in The Hague,
Vincent had created a drawing and
a lithograph of this subject. It is not
surprising, therefore, that when he
decided much later to transpose the
image into the oil-painting medium,
the resultant canvas should have a
distinctively graphic quality.

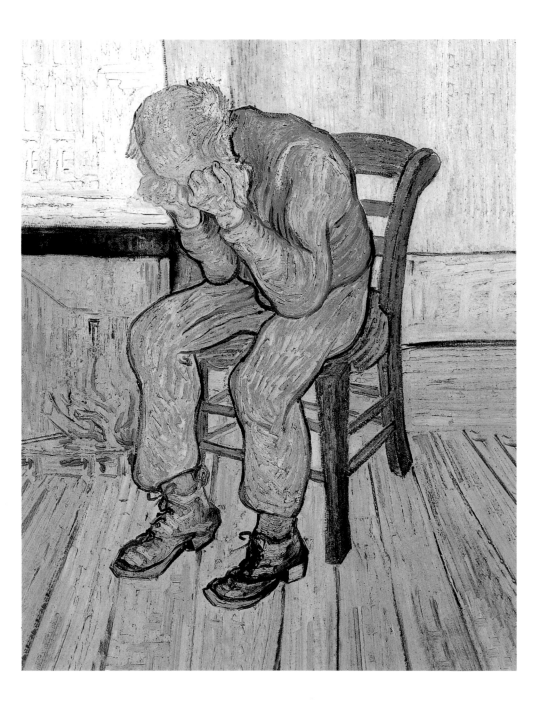

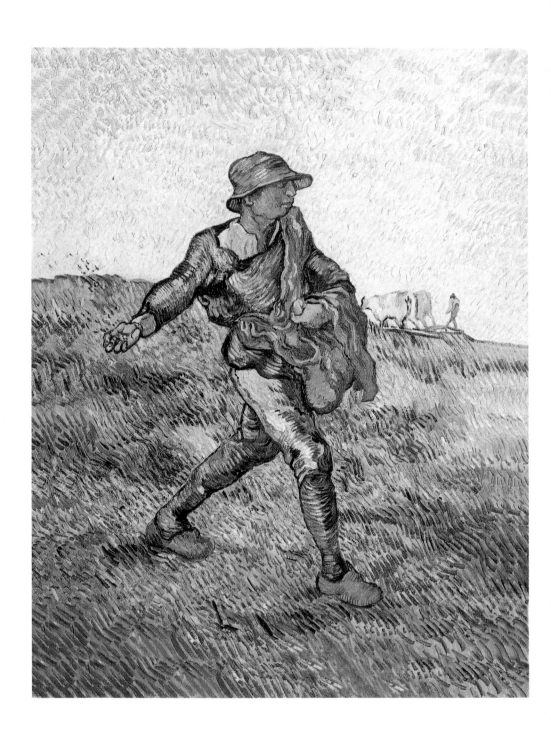

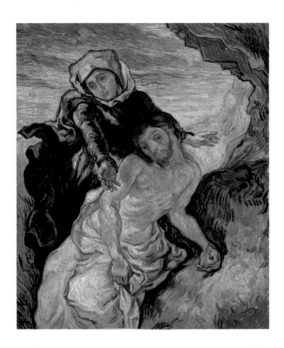

[72] *The Sower (after Millet)*
Saint-Rémy, late October 1889
In 1881, Vincent had made a drawing of Millet's famous painting. Eight years later, and beset by major breakdowns, he completed this version in oils. Although he had misgivings about recreating Millet's works, he believed that by interpreting them he could perhaps gain some comfort.

[73] *Pietà (after Delacroix)*
Saint-Rémy, September 1889
When painting variations of works by Rembrandt and Delacroix, Vincent focused on what he perceived as each artist's primary technique: 'One, Delacroix, proceeds by way of colours, the other, Rembrandt, by values, but they're on a par' (651). Delacroix's biblical image has been freely improvised; and, intriguingly, Vincent's own features have been superimposed onto Christ's face.

Additional to these improvisations stimulated by his own portraits, Vincent also produced paintings inspired by other artists' works, believing that, in this way, he was making 'translations' in paint rather than precise copies. Prints of well-known paintings by some of his favourite artists, including Jean-François Millet and Eugène Delacroix (1798–1863), were used by Vincent to create colourful 'free variations', much as a composer of music would do [72, 73]. Theo regarded the paintings that Vincent based on Millet's images as some of the best works his brother had completed to date. But unlike the paintings Vincent created as a personal response to nature, these aesthetic exercises were, of necessity, much more synthetic in character.

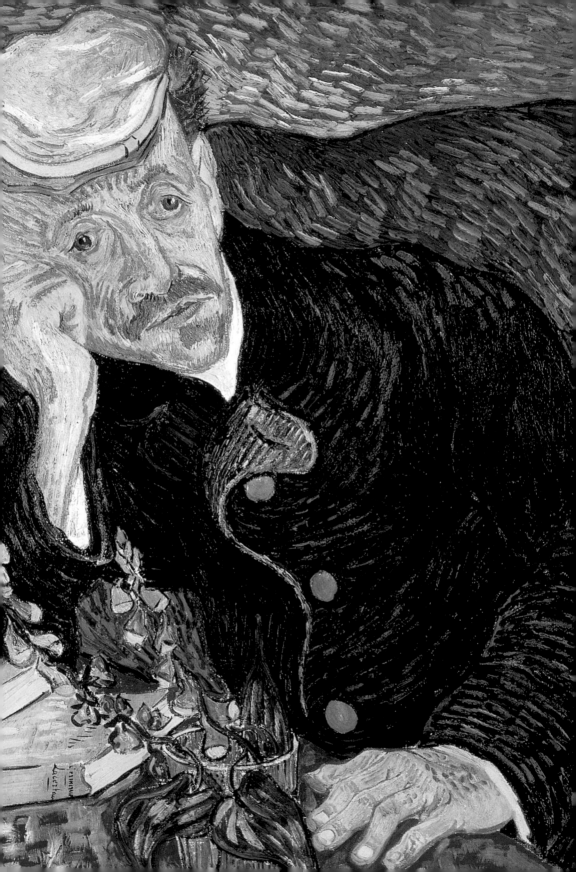

CHAPTER 5

Auvers-sur-Oise

'Sad but gentle but clear and intelligent, that's how many portraits should be done'

After a year in the asylum at Saint-Rémy, where he had endured many psychotic attacks and yet had managed, between episodes, to paint remarkable canvases, Vincent finally asked Dr Peyron if he could be discharged. He wished to live once more in the north of France, where he hoped that the climate and environment would aid his recovery. Indeed, he felt that his mental condition was deteriorating in the asylum. However, he was later to confess to his sister Wil that, despite this decline in his health, his pace of working had not slackened between attacks: 'In the last few days at St-Rémy I worked in a frenzy' (RM19).

It was this self-confessed manic energy that Theo feared most when Vincent, unaccompanied, set off by train for Paris. Fortunately, he arrived safely on Saturday 17 May 1890, staying for a few days with Theo, his wife Jo (Johanna van Gogh-Bonger, 1862–1925), and their son (Vincent Willem, 1890–1978). On 20 May, following the plan devised by Theo, Vincent left for Auvers-sur-Oise, a quiet rural village to the northeast of Paris; here he was to live for the last few months of his life. A countryman at heart, Vincent found the village to be a delightful place, and a welcome contrast with Paris: 'for the moment I still fear the noise and the bustle of Paris' (RM19). As Vincent had begun his artistic career as a painter of rural life in the Netherlands, he relished the opportunity to depict once more the countryside of northern Europe [74].

During his stay in Auvers, Vincent was placed under the benign supervision of Dr Paul-Ferdinand Gachet (1828–1909), a homeopathic doctor. For a number of years, Dr Gachet had been a close friend of many artists who had painted the quaint village and its surrounding countryside. A keen amateur artist, he was also an enthusiastic collector of paintings and antiques. Theo had been assured by the Impressionist painter

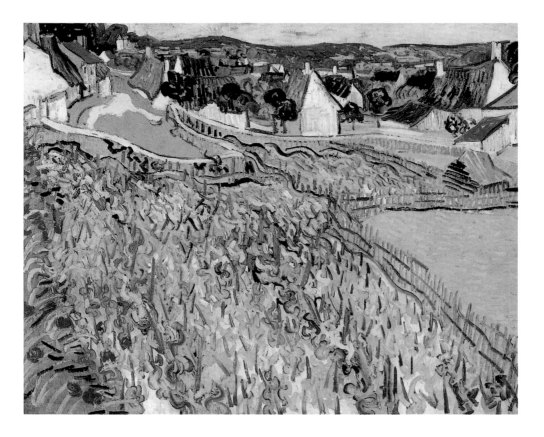

[74] *Vineyards at Auvers*
Auvers-sur-Oise, June 1890
Soon after his arrival in Auvers, Vincent wrote to Wil describing the village's picturesque qualities. He felt that its rural character could form the basis of interesting compositions: 'Here there are roofs of mossy thatch which are superb, and of which I'll certainly do something' (RM19).

Camille Pissarro (1830–1903) that Dr Gachet would be the ideal person for Vincent to consult should he become ill once more. After he had rented a room in the café-inn run by Monsieur Arthur Gustave Ravoux (b. 1848) and his wife Louise, and had started painting once again, Vincent became a frequent visitor to the impressive villa that Dr Gachet shared with his son and daughter, his wife having died some years earlier. Vincent found Dr Gachet to be a generous host and intelligent raconteur: 'We were friends, so to speak, immediately' (879). Yet Vincent detected an underlying anxiety and sadness in his new friend's demeanour, traits that he tried to express in his famous portrait of him [75]. He believed strongly that, in portraits such as this, 'photographic resemblance' should be avoided at all costs, replaced by 'passionate expressions',

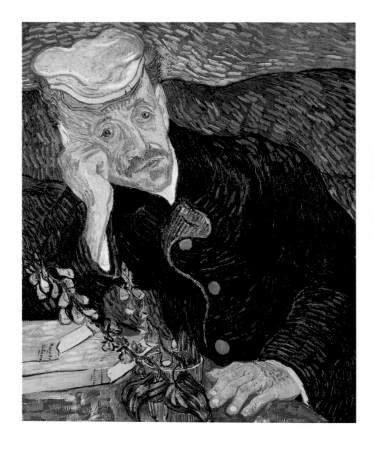

[75] *Portrait of Doctor Gachet*
Auvers-sur-Oise, June 1890
Vincent noted that his portrait of
Dr Gachet revealed 'an expression
of melancholy which might often
appear to be a grimace' (886).
Technically, the dominant feature
of the painting is its elaborate
patterning. The swirling effect
has been achieved by building up
networks of short, light-coloured
lines over a series of darker grounds.

thus intensifying the representation of the model's inherent character (879).

Vincent also painted an unusual portrait of Marguerite Gachet (1869–1949), Dr Gachet's twenty-year-old daughter [76]. Although the subject matter is typical of many nineteenth-century interiors – an elegant young woman playing a piano, as in certain of Renoir's charming paintings – Vincent's portrait is bold, almost brash, in its use of thick paint and heavy outlining of forms. Thus his image avoids sentimental prettiness, and is full of rhythmic touches of pigment.

But Vincent also hoped to produce paintings in Auvers that had a more pensive and gentle quality than the Gachet portraits. The result was his tender portrayal of Adeline

[76] *Marguerite Gachet at the Piano*

Auvers-sur-Oise, June 1890

Even at this late stage in his career, Vincent enjoyed mixing styles in a single painting: here, impasto is used to portray the flowing dress; outlining, inspired by his Japanese print collection, heightens the forms of the piano, stool and candle; and the orange spots on the green wallpaper convey his ongoing fascination with pointillism. Vincent saw the double-square, vertical format of the portrait as being reminiscent of Japanese scroll paintings.

[77] *Portrait of Adeline Ravoux*
[77] *Portrait of Adeline Ravoux*
Auvers-sur-Oise, June 1890
One of Vincent's few three-quarter-length portraits in profile, this painting captures the girl's slight unease while posing. The colouring is a harmony of deep blues punctuated by highlights of gold. Striations suggest forms and volumes in an almost sculptural manner. Although Adeline had initially been disappointed with her portrait, eventually she came to admire it.

Ravoux (1877–1965), the thirteen-year-old daughter of the innkeeper and his wife [77]. In 1956, at the age of seventy-nine, she published a fascinating memoir of Vincent's last months in Auvers, including an account of the portrait's completion. She stressed how pleasant and calm the artist had been when she knew him – just as Dr Peyron had noted after Vincent had recovered from attacks in the asylum. By 1956, she estimated that she was probably the last person alive who had known Van Gogh in Auvers.

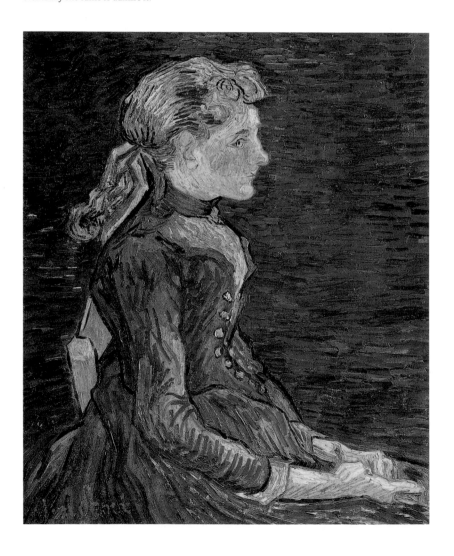

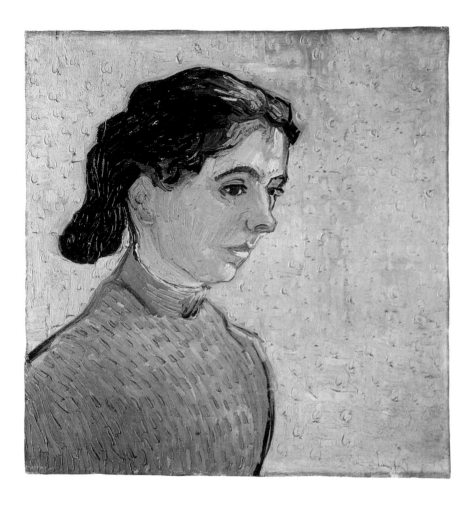

A painting of another young woman seems to epitomize the qualities that Vincent believed contemporary portraits should possess [78]: 'Sad but gentle but clear and intelligent, that's how many portraits should be done, that would still have a certain effect on people at times' (886). In complete contrast, his portrait of a young man, most likely an imaginary work, suggests a mythological creature – a sprite [79]. This image is yet another example of Vincent's 'apparitions' – portraits intended to unnerve future viewers. Haunting in a very different manner, however, are some of his portraits of young women that display a poetic, emblematic quality [80].

[78] *Portrait of a Young Woman*
Auvers-sur-Oise, June 1890
The composition of this elegant portrait is asymmetrical and informal. Although Vincent adopted a sketch-like technique, nevertheless he was able to convey his model's pensive mood with great sensitivity.

[79] *Young Man with Cornflower*
Auvers-sur-Oise, June 1890
The subject of this enigmatic
portrait perhaps relates to Vincent's
familiarity with Greek mythology,
and in particular with Pan, the god
of pastures, flocks and woods. The
elaborate striations unify the picture
plane of this visionary work.

'I'd like to paint men or women
with that je ne sais quoi of
the eternal ... which we try to
achieve through the radiance
itself, through the vibrancy
of our colorations' (673)

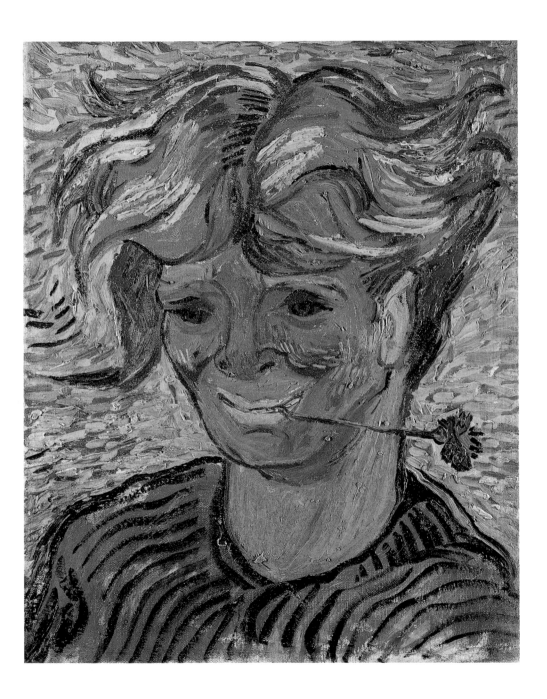

[80] *Peasant Girl in Straw Hat*
Auvers-sur-Oise, late June 1890
Reminiscent of the type of folk art
that Vincent admired, the figure in
this portrait is boldly delineated.
The young woman posed in his
studio, a room in the inn; the
elaborate background of wheat
is simply a memorable decorative
device.

Despite suffering from periods of anxiety and depression, Vincent completed an extremely large body of work in Auvers – more than eighty paintings and sixty-four drawings in only seventy days. But this manic energy had taken its toll; on 27 July 1890, aged only thirty-seven, Vincent walked into a field and shot himself in the chest. Fatally wounded, he returned to the inn, where two days later he died, with Theo at his side.

Although it would appear that Vincent never painted Theo's portrait, a drawing dating from 1887, when they were sharing

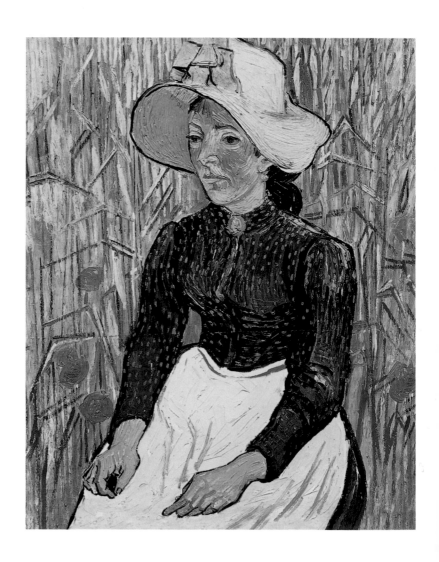

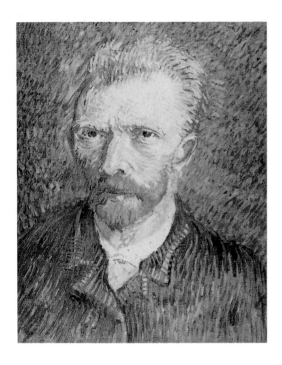

an apartment in Paris – perhaps depicts him in profile. And
in his last poignant letter to Wil – dated 13 June 1890, forty-
six days before his death – he expressed his wish to paint her
in the future: 'I do hope to do your portrait one day. I'm very
curious to have another letter from you, more soon, I hope,
I kiss you affectionately in thought. Ever yours, Vincent' (886).

Vincent's portraits are immediately accessible, yet deeply
mysterious. They possess an intensity that strikes an
emotional chord with people worldwide. As he predicted, his
portraits *do* appear today as 'apparitions' from the past – *his*
past. And the most enigmatic apparitions that he painted
were his confessional self-portraits [81]. Vincent's body of
portraits represents a compelling record of his times, and his
highly original mind.

Sources of Quotations

All displayed quotations are taken from *Vincent van Gogh – The Letters*, published in 2009 by Thames & Hudson.

INTRODUCTION, PAGE 8
'And painted portraits have a life of their own that comes from deep in the soul of the painter...'
Letter 547, to Theo van Gogh, on 14 December 1885

CHAPTER 1, PAGE 22
'Ah, it seems to me more and more that people are the root of everything'
Letter 595, to Theo van Gogh, on or about 11 April 1888

CHAPTER 2, PAGE 40
'...it gives me air when I make a painting...'
Letter 574, to Willemien van Gogh, late October 1887

CHAPTER 3, PAGE 54
'But what I hope to achieve is to paint a good portrait'
Letter 574, to Willemien van Gogh, late October 1887

CHAPTER 4, PAGE 84
'And little by little I can come to consider madness as being an illness like any other'
Letter 772, to Theo van Gogh and Jo van Gogh-Bonger, on 9 May 1889

CHAPTER 5, PAGE 100
'Sad but gentle but clear and intelligent, that's how many portraits should be done'
Letter 886, to Willemien van Gogh, on 13 June 1890

Further Reading

Van Gogh's Correspondence

Vincent van Gogh, *Vincent van Gogh – The Letters*, 6 vols (London & New York: Thames & Hudson, 2009)
Vincent van Gogh, *The Real Van Gogh: The Artist and His Letters* (London: Royal Academy of Arts, 2010)
Grant, Patrick, *The Letters of Vincent van Gogh: A Critical Study* (Edmonton: AU Press, 2014)

Van Gogh's Drawings

Ives, Colta F., Susan A. Stein, Sjraar van Heugten and Marije Vellekoop, *Vincent van Gogh: The Drawings* (New York: Metropolitan Museum of Art; Amsterdam: Van Gogh Museum; New Haven: Yale University Press, 2005)
Van Heugten, Sjraar, and Roelie Zwikker, *Vincent van Gogh: Drawings*, 4 vols (Amsterdam: Van Gogh Museum; Aldershot, UK: Lund Humphries, 1996–2007)
Van Heugten, Sjraar, Marije Vellekoop and Roelie Zwikker, *Van Gogh: The Master Draughtsman* (London: Thames & Hudson, 2005)

Van Gogh's Paintings

Thomson, Belinda, *Van Gogh Paintings: The Masterpieces* (London: Thames & Hudson, 2007)
Vellekoop, Marije, *Van Gogh at Work* (Amsterdam: Van Gogh Museum; Brussels: Mercatorfonds; New Haven and London: Yale University Press, 2013)
Walther, Ingo F., and Rainer Metzger, *Van Gogh: The Complete Paintings* (Cologne: Taschen, 1997)

Van Gogh and Romanticism

Rosenblum, Robert, *Modern Painting and the Northern Romantic Tradition: Friedrich to Rothko* (London: Thames & Hudson, 1975)

Van Gogh and Gauguin

Druick, Douglas W., and Peter Kort Zegers, *Van Gogh and Gauguin: The Studio of the South* (London: Thames & Hudson, 2001)
Gayford, Martin, *The Yellow House: Van Gogh, Gauguin and Nine Turbulent Weeks in Arles* (London: Fig Tree/Penguin Books, 2006)

Psychological Factors

Lubin, Albert J., *Stranger on the Earth: A Psychological Biography of Vincent van Gogh* (New York: Da Capo Press, 1996)
Jamison, Kay Redfield, *Touched with Fire: Manic-Depressive Illness and the Artistic Temperament* (New York: Free Press/Simon & Schuster, 1994)
Vellekoop, Marike, Hans Luijten, Nienke Bakker, Louis van Tilborgh and Laura Prins, *On the Verge of Insanity: Van Gogh and His Illness* (Amsterdam:

Van Gogh Museum; Brussels: Mercatorfonds;
New Haven and London: Yale University Press, 2016)

Biographical Context
Naifeh, Steven, and Gregory White Smith, *Van Gogh: The Life* (London: Profile Books, 2011)

Murphy, Bernadette, *Van Gogh's Ear: The True Story* (London: Chatto & Windus, 2016)
Ozanne, Marie-Angélique, and Frédérique de Jode, *Theo: The Other Van Gogh* (New York: Magowan Publishing LLC and Vendome Press, 2004)

Picture Credits

All works are by Vincent van Gogh. They are listed by their full titles, and measurements are given, where known, in centimetres (and inches), height before width. Bracketed numerals indicate the image number.

[1] *Head of a Peasant Woman with a Red Cap.* 43.2 × 30 (17 × 11¾). (Vincent van Gogh Foundation), Van Gogh Museum, Amsterdam. **[2]** *Portrait of a Woman with a Red Ribbon.* 60 × 50 (23⅝ × 19¾). Private Collection, New York. **[3]** *Young Man with a Cap.* 47.5 × 39 (18¹¹⁄₁₆ × 15 ⅜). Private Collection, Zurich. **[4]** *Portrait of a One-Eyed Man.* 56.5 × 36.6 (22¼ × 14⅜). (Vincent van Gogh Foundation), Van Gogh Museum, Amsterdam. **[5]** *Still-Life: French Novels.* 54.4 × 73.6 (21⁷⁄₁₆ × 29). (Vincent van Gogh Foundation), Van Gogh Museum, Amsterdam. **[6]** *Self-Portrait.* 44 × 35.5 (17 ⁵⁄₁₆ × 14). Musée d'Orsay, Paris. **[7]** *Woman Sewing* (detail). 62.5 × 47.5 (24⅝ × 18¹¹⁄₁₆). Rijksmuseum Kröller-Müller, Otterlo. **[8]** *Sien with Cigar, Sitting on the Ground by the Stove.* 45.5 × 56 (17⅞ × 22¹⁄₁₆). Rijksmuseum Kröller-Müller, Otterlo. **[9]** *Girl with a Pinafore.* 48.6 × 25.6 (19⅛ × 10¹⁄₁₆). William Francis Warden Fund. Museum of Fine Arts, Boston. **[10]** *Old Man with a Top Hat.* 60 × 36 (23⅝ × 14³⁄₁₆). (Vincent van Gogh Foundation), Van Gogh Museum, Amsterdam. **[11]** *Head of a Peasant Woman.* 40.2 × 33.3 (15⅞ × 13⅛). (Vincent van Gogh Foundation), Van Gogh Museum, Amsterdam. **[12]** *Young Man with a Pipe.* 39.9 × 28.4 (15⅝ × 11³⁄₁₆). (Vincent van Gogh Foundation), Van Gogh Museum, Amsterdam. **[13]** *Head of a Peasant with a Pipe.* 44 × 32 (17⅝ × 12⅝). Rijksmuseum Kröller-Müller, Otterlo. **[14]** *Head of a Woman.* 14.2 × 10.4. (5½ × 4¹⁄₁₆). (Vincent van Gogh Foundation), Van Gogh Museum, Amsterdam. **[15]** *Head of a Young Peasant in a Peaked Cap.* 39 × 30.5 (15⅜ × 12). Musée Royaux des Beaux-Arts de Belgique, Brussels. **[16]** *The Potato Eaters.* 82 × 114 (32¼ × 44⅞). (Vincent van Gogh Foundation), Van Gogh Museum, Amsterdam. **[17]** *Weaver near an Open Window.* 67.9 × 93.4 (26 ¾ × 36 ¾). Bayerische Staatsgemälde-Sammlungen, Neue Pinakothek, Munich. **[18]** *Head of a Peasant Woman in a White Cap.*

46.4 × 35 (18¼ × 13¾). National Gallery of Scotland, Edinburgh. **[19]** *Head of a Peasant Woman in a White Cap.* 41 × 30.5 (16 ⅛ × 12). Foundation E.G. Bührle Collection, Zürich. **[20]** *Still Life with Bible.* 65.7 × 78.5 (25⅞ × 30¹⁵⁄₁₆). (Vincent van Gogh Foundation), Van Gogh Museum, Amsterdam. **[21]** *View of Paris from Vincent's Room in the Rue Lepic.* 45.9 × 38.1 (18¹⁄₁₆ × 15). (Vincent van Gogh Foundation), Van Gogh Museum, Amsterdam. **[22]** Henri de Toulouse-Lautrec, *Portrait of Vincent van Gogh.* 57 × 46 (22⁷⁄₁₆ × 18⅛). (Vincent van Gogh Foundation), Van Gogh Museum, Amsterdam. **[23]** *Two Self-Portraits and Several Details.* 31.1 × 24.4 (12¼ × 9⅝). (Vincent van Gogh Foundation), Van Gogh Museum, Amsterdam. **[24]** *Self-Portrait.* 41 × 32.5 (16 ⅛ × 12¹³⁄₁₆). Joseph Winterbotham Collection, Art Institute of Chicago. **[25]** *Portrait of Alexander Reid, Scottish Art Dealer.* 42 × 33 (16½ × 13). CSG CIC Glasgow Museums and Libraries Collections. **[26]** *Self-Portrait with a Straw Hat.* 34.9 × 26.7 (13¾ × 10½). City of Detroit Purchase. Detroit Institute of Arts. **[27]** *Agostina Segatori Sitting in the Café du Tambourin.* 55.5 × 47 (21⅞ × 18½). (Vincent van Gogh Foundation), Van Gogh Museum, Amsterdam. **[28]** *The Italian Woman.* 81.5 × 60.5 (32¹⁄₁₆ × 23¹³⁄₁₆). Musée d'Orsay, Paris. **[29]** *Portrait of Père Tanguy.* 92 × 75 (36 ¼ × 29½). Musée Rodin, Paris. **[30]** *Self-Portrait as a Painter.* 65.1 × 50 (25⅝ × 19¹¹⁄₁₆). (Vincent van Gogh Foundation), Van Gogh Museum, Amsterdam. **[31]** *Snowy Landscape with Arles in the Background.* 50 × 60 (19¹¹⁄₁₆ × 23⅝). Private Collection, London. **[32]** *A Pork-Butcher's Shop seen from a Window.* 39.7 × 33.1 (15⅝ × 13). (Vincent van Gogh Foundation), Van Gogh Museum, Amsterdam. **[33]** *Old Woman of Arles.* 58 × 42 (22¾ × 16 ½). (Vincent van Gogh Foundation), Van Gogh Museum, Amsterdam. **[34]** *Portrait of a Man.* 65 × 54.5 (25⁹⁄₁₆ × 21½). Rijksmuseum Kröller-Müller, Otterlo. **[35]** *Mousmé.* 73.3 × 60.3 (28⅞ × 23¾). Chester Dale Collection (1963.10.151). National Gallery of Art, Washington D.C. **[36]** *The Seated Zouave.* 81 × 65 (31⅞ × 25⁹⁄₁₆). Private Collection, Argentina. **[37]** *The Zouave.* 31.9 × 24.3 (12⁹⁄₁₆ × 9⁹⁄₁₆). Gift, Justin K. Thannhauser, 1978,

Thannhauser Collection, The Solomon R. Guggenheim Museum, New York. [38] *Portrait of the Postal Officer, Joseph Roulin.* 81.3 × 65.4 (32 × 25¾). Museum of Fine Arts, Boston. [39] *Portrait of the Postal Officer, Joseph Roulin.* 32.1 × 24.4 (12⅝ × 9⅝). Digital image courtesy of the Getty's Open Content Program. J.Paul Getty Museum, Los Angeles. [40] *Portrait of Armand Roulin.* 65 × 54.1 (25½ × 21¼). Museum Folkwang, Essen. [41] *Portrait of Camille Roulin ('The Schoolboy').* 63 × 54 (24¾ × 21¼). Museu de Arte de São Paulo, São Paulo. [42] *Madame Roulin with her Baby.* 63.5 × 51 (25 × 20⅛). Robert Lehman Collection, 1975. Metropolitan Museum of Art, New York. [43] *The Baby Marcelle Roulin.* 35 × 23.9 (13¾ × 9⁷⁄₁₆). Chester Dale Collection. National Gallery of Art, Washington D.C. [44] *Portait of Patience Escalier.* 69 × 56 (27⅝ × 22¹⁄₁₆). Private Collection. [45] *Portrait of Patience Escalier.* 49.4 × 38 (19⁷⁄₁₆ × 14¹⁵⁄₁₆). Bequest of Grenville L. Winthrop. Harvard Art Museums/Fogg Museum, Cambridge, Mass. [46] *Portrait of Eugène Boch ('The Poet').* 60 × 45 (23⅝ × 17¾). Musée d'Orsay, Paris. [47] *Portrait of Milliet, Second Lieutenant of the Zouaves ('The Lover').* 60 × 50 (23⅝ × 19¹¹⁄₁₆). Rijksmuseum Kröller-Müller, Otterlo. [48] *Self-Portrait Dedicated to Paul Gauguin.* 61.5 × 50.3 (24³⁄₁₆ × 19³⁄₁₆). Bequest from the Collection of Maurice Wertheim, Class of 1906. Harvard Art Museums/Fogg Museum, Cambridge, Mass. [49] *Self-Portrait Dedicated to Charles Laval.* 46 × 39 (18⅛ × 15⅜). Private Collection. [50] Émile Bernard, *Self-Portrait with Portrait of Gauguin,.* 46 × 56 (18⅛ × 22¹⁄₁₆). (Vincent van Gogh Foundation), Van Gogh Museum, Amsterdam. [51] *The Yellow House.* 72 × 91.5 (28⅜ × 36). (Vincent van Gogh Foundation), Van Gogh Museum, Amsterdam. [52] *Vincent's Chair with his Pipe.* 91.8 × 73 (36⅛ × 28¾). Purchase, Courtauld Fund, 1924. National Gallery, London. [53] Paul Gauguin, *Van Gogh Painting Sunflowers,.* 73 × 91 (28¾ × 35⅞). (Vincent van Gogh Foundation), Van Gogh Museum, Amsterdam. [54] *Portrait of Paul Gauguin.* 38.2 × 33.8 (15¹⁄₁₆ × 13⁵⁄₁₆). (Vincent van Gogh Foundation), Van Gogh Museum, Amsterdam. [55] *L'Arlésienne: Madame Ginoux with Books.* 91.4 × 73.7 (36 × 29). Bequest of Sam A. Lewisohn, 1951. Metropolitan Museum of Art, New York. [56] *Portrait of Doctor Félix Rey.* 64 × 63 (25¼ × 24⅝). Photo 2010 Pushkin Museum of Fine Arts, Moscow. [57] *Self-Portrait with Pipe and Bandaged Ear.* 51 × 45 (20¹⁄₁₆ × 17¾). Private Collection. [58] *Self-Portrait with Bandaged Ear.* 50 × 60 (19¹¹⁄₁₆ × 23⅝). Samuel Courtauld bequest, 1948. Photo the Samuel Courtauld Trust, The Courtauld Gallery, London. [59] *'La Berceuse' [Portrait of Madame Roulin].* 92 × 73 (36¼ × 28¾). Rijksmuseum Kröller-Müller, Otterlo/Peter Barritt/Alamy Stock Photo. [60] *Window in the Studio.* 62 × 47.6 (24⅜ × 18¾). (Vincent van Gogh Foundation), Van Gogh Museum, Amsterdam. [61] *Vestibule of the Asylum.* 61.6 × 47.1 (24¼ × 18⁹⁄₁₆). (Vincent van Gogh Foundation), Van Gogh Museum, Amsterdam. [62] *Self-Portrait.* 51.5 × 45 (20¼ × 17¾). Nasjonalgalleriet, Oslo/Photo Nasjonalmuseet, Oslo. [63] *Portrait of a Patient in the Saint-Paul Asylum.* 32.2 × 23.3 (12¹¹⁄₁₆ × 9³⁄₁₆). (Vincent van Gogh Foundation), Van Gogh Museum, Amsterdam. [64] *Self-Portrait.* 57.2 × 43.8 (22½ × 17¼). Collection of Mr. & Mrs. John Hay Whitney. National Gallery of Art, Washington, D.C. [65] *Portrait of Trabuc, an Attendant at the Saint-Paul Asylum.* 61 × 46 (24 × 18¼). Kunstmuseum Solothurn. [66] *Portrait of Madame Trabuc.* 63.7 × 48 (25¹⁄₁₆ × 18⅞). Hermitage State Museum, St Petersburg. [67] *The Gardener or Young Peasant.* 61 × 50 (24 × 19¹¹⁄₁₆). Galleria Nazionale d'Arte Moderna, Rome. [68] *Self-Portrait.* 65 × 54.2 (25⅝ × 21⅜). Musée d'Orsay, Paris. [69] *Self-Portrait.* 40 × 31 (15¾ × 12³⁄₁₆). Private Collection, Switzerland. [70] *L'Arlésienne [Madame Ginoux].* 65 × 49 (25⅝ × 19⁵⁄₁₆). Rijksmuseum Kröller-Müller, Otterlo. [71] *Old Man in Sorrow [on the Threshold of Eternity].* 81 × 65 (31⅞ × 25⅝). Rijksmuseum Kröller-Müller, Otterlo. [72] *The Sower [after Millet].* 80.8 × 66 (31¾ × 26). Private Collection. [73] *Pietà [after Delacroix].* 73 × 60.5 (28¾ × 23¾). (Vincent van Gogh Foundation), Van Gogh Museum, Amsterdam. [74] *Vineyards at Auvers.* 65.1 × 80.3 (25⅝ × 31⅝). Funds given by Mrs. Mark C. Steinberg. Saint Louis Art Museum, St Louis. [75] *Portrait of Doctor Gachet.* 67 × 56 (26⅜ × 22¹⁄₁₆). Private collection. [76] *Marguerite Gachet at the Piano.* 102.5 × 50 (40⅜ × 19¾). Öffentliche Kunstsammlung, Kunstmuseum Basel. [77] *Portrait of Adeline Ravoux.* 73.7 × 54.7 (29 × 21½). Private collection. [78] *Portrait of a Young Woman.* 51 × 49 (20¹⁄₁₆ × 19⅝). Rijksmuseum Kröller-Müller, Otterlo. [79] *Young Man with Cornflower.* 39 × 30.5 (15⅜ × 12). Private collection. [80] *Peasant Girl in Straw Hat.* 92 × 73 (36¼ × 28¾). Private Collection. [81] *Self-Portrait.* 46.5 × 35.5 (18¼ × 14). Foundation E.G. Bührle Collection, Zürich.